741·6

"There are no rules."

—SUPON PHORNIRUNLIT

acknowledgments

Project & Creative Director
SUPON PHORNIRUNLIT

Jacket Designer
SCOTT BOYER

Book Designers
SCOTT BOYER
KATE LYDON

Cover Illustrator
JAE WEE

Managing Editor
SUPON PHORNIRUNLIT

Editors
CLARE JAMES
WAYNE KURIE
STEPHEN SMITH

Back Cover Contributors
TOP TO BOTTOM:
CAHAN & ASSOCIATES
VIVA DOLAN COMMUNICATIONS & DESIGN
PRESSLEY JACOBS DESIGN

Breaking the Rules in Publication Design
©2001 by Supon Design Group

ISBN 0-942604-83-0

Library of Congress Catalog Card Number 00-092828

Distributed in North America to the trade and art markets by:
North Light Books
an imprint of F&W Publications, Inc.
1507 Dana Avenue
Cincinnati, Ohio 45207
1 (800) 289-0963

Distributed throughout the rest of the world by:
HBI/HarperCollins
10 East 53rd Street
New York, New York 10022

Published by:
Madison Square Press
10 East 23rd Street
New York, New York 10010
Fax: (212) 979-2207
E-mail: madisonsqpress@aol.com

Printed in Hong Kong

Breaking the rules in puBLiCAtion DESiGN

SUPON DESIGN GROUP

table of contents

Whether it's an innovative brochure, an irreverent magazine, or an interactive Web site, publication design is forever in flux. The transformations have been significant and sweeping. Content and format, typography and texture, copy and color—even media themselves—are constantly evolving.

While the changes may seem haphazard, today's publication design is guided by an intricate chain of influences: cultural climate, business demands, industry peculiarities, technological tools, target audiences, budgetary considerations, individual design sensibilities... The list goes on and on. It's no surprise that graphic design solutions are as divergent as the factors and personalities that determine a publication's substance.

But whether it's through creative inspiration or technological invention, the most sensational solutions are always rendered by the designer who knows conventional design rules—and how to reinvent them in unique and groundbreaking ways. The diverse and open nature of the publication affords designers with exciting options.

"Publication design allows you to work with a true variety of content," says Hans Teensma, art director at Impress, Inc. in Northampton, Massachusetts. "It can be serious, humorous, fiction, or nonfiction. It's never dull."

Today's publication design is taking on so many directions, it's impossible to point to one prevailing style or dominant trend. And, as you'll see in this book, that's a good thing. The assortment of graphic solutions gracing the front pages, middle pages, and home pages of publications has rendered an inspiring and unpredictable mix of visuals.

Such variety wasn't exactly the case when the first publications came into being. Prior to the first modern print presses in the 17th century, publications were limited by both cultural and technological considerations. A brazen illustration or unconventional type treatment was not likely to be socially acceptable, let alone possible with the industry's existing technology.

After the turn of the 20th century, the industrial revolution—and certain prominent artists of the day—influenced the direction of design. Technological and aesthetic innovations inspired new ways to think about texture, pattern, and color. It wasn't until the 20s, however, that extensive color photos, bleed pages, montage, and unconventional typography became commonplace in publications.

Nothing has revolutionized the parameters of publications more than the computer. Indeed, modern technology affords designers with more format, typographic, and color options than ever. The latest and greatest software has rendered a heretofore unimaginable range of visual options.

But such flexibility can be a double-edged sword. "New technology has good and bad aspects," says Tim Walker of Walker Creative in Fayetteville, Arkansas. "There are so many more tools to experiment. But you have to harness that technology and not let it dictate the parameters for design."

Computers have not only expanded the boundaries of print, they has also created new forms of visual communications. Web sites and CD ROMs have entered—and dramatically influenced—the all-paper world of publication design. Furthermore, electronic publishing offers something critical to the evolving nature of business communications: flexibility.

"Our CD ROM is portable and can be distributed to all types of clients," explains Patty Jensen of Jensen Design Associates in Long Beach, California. "We can tailor it to a particular client and it's cross-platform now so more people can use it. The ability to constantly update our CD and Web site is really key."

Tim Larsen of Larsen Design + Interactive in Minneapolis, Minnesota says that new media has driven change in all types of publications, particularly promotions. In fact, he believes print and electronic pieces have become virtually interdependent. "These media create an incredible communication opportunity," says Larsen.

"Print promotions now correlate with online promotions and online promotions engage users through an interactive experience."

Technology aside, clients' attitudes and new graphic approaches are the driving forces behind today's publication design. Not only are clients increasingly able to articulate their objectives, they are more willing to consider heretofore unthinkable design concepts. From experimental typography to innovative layouts to creative copy, a variety of fresh design solutions are prevalent in today's publications.

Still, the nature of most publications lies in the written word. Whatever the size or purpose of the piece, copy plays a pivotal role in articulating meaning and establishing a unique voice. Design must therefore work in concert with the text for the visual solutions to be meaningful and compelling.

Frank Viva of Toronto-based Viva Dolan Communications & Design points out that design and text should carry equal weight and complement each other in the process. "The visual side is content, not decoration. It can relieve some of the pressure of writing and vice versa. Both can support and make the other stronger."

Ultimately, publication design is about telling a story through pictures and words. But memorable publication design doesn't just stop at communicating ideas— it demonstrates the design sensibilities that allow form and content to blend in inventive and unforeseen ways. That can mean transforming ordinary ideas into extraordinary images, or simply inventing a fresh use of color. It can mean a daring headline or restrained typography.

What does the future hold for publication design? No doubt tomorrow's road will be paved by the disparate ingredients that make up current design solutions: cultural zeitgeist, budgetary factors, technological breakthroughs, and the ever-present influence—personal taste. If the diverse and dynamic work featured in this book is any indication, the constantly evolving rules of publication design are meant to be broken.

PHOTO BY LARRY OLSEN

SUPON PHORNIRUNLIT

Supon Phornirunlit serves as creative director for Supon Design Group, a company he founded 12 years ago. A prodigy of design schools in Thailand, Japan and the U.S., Supon excels in establishing the vision behind high-profile design projects. He is skilled in the creation and implementation of promotional and marketing concepts, and has spearheaded many successful campaigns, including the design and development of Olympic sponsorship efforts of both IBM and Coca-Cola, and recruitment efforts on behalf of The George Washington University.

He and his team have earned top awards from numerous organizations, including the Broadcast Designers' Association, American Institute of Graphic Art, Direct Marketing Association of Washington, and numerous Addy Awards from the American Advertising Federation. Publications including *Creativity*, *Critique*, *HOW*, *Publish*, and *Home Office* have recognized his work with awards for design from graphics to interiors. Supon has been the subject of cover stories for a number of magazines and publications worldwide, including *Asia Inc*, *Small Business News*, *Novum*, *Studio*, *art4d*, *Gentlemen's Magazine*, and *The Bangkok Post*.

Supon has also served on the boards of the Art Directors Club of Metropolitan Washington and the Broadcast Designers' Association. He regularly speaks and judges at various organizations and schools.

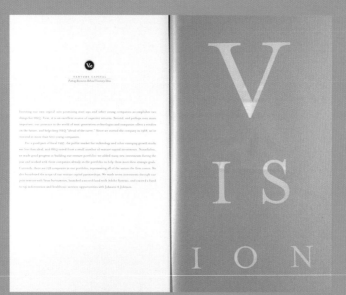

BREAKING THE RULES IN PUBLICATION DESIGN

When your work speaks for itself, don't interrupt.
—Henry J. Kaiser

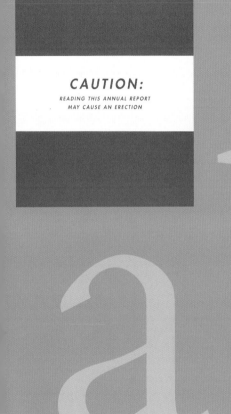

CAUTION:
READING THIS ANNUAL REPORT
MAY CAUSE AN ERECTION

nnual reports have changed dramatically. No longer just a financial document for publicly held companies, the publication now serves all types of businesses and equally as many functions. It can be an image piece or an employee-relations discourse, a management treatise or a marketing tool.

Accordingly, annual reports are taking on broader design objectives. The piece must communicate information professionally, yet be visually compelling. It must maintain a comprehensive perspective, yet portray a distinctive image. In the final analysis, according to Steven Sikora of Design Guys: "An annual report is the place where a company really needs to put its personality out front."

Thankfully, expressing personality is more conducive to creative design than reporting how much money a company made. Twenty years ago, annual reports were generally conservative and text-heavy, sandwiched by a glib letter from the CEO and a litany of confusing financials. Today, however, the documents require "personality posturing." They must distinguish a company's party line from its bottom line.

Expressing who you are in annual reports is often accomplished by focusing on a single major theme. The idea is that one big concept can be emblematic of a company's market position or vision statement.

For example, the 1997 Annual Report for Platinum Technology (page 22), designed by Pressley Jacobs Design, drives home the importance of information technology with symbolic images, dramatic photography, and riveting copy. In a similar vein, Design Guys uses the "Challenge and Change" headline as a thematic springboard for Public International Radio's 1995 Annual Report. Bold text and powerful graphics all reflect the recurring motif (page 23).

The role clients play has changed significantly in the world of annual report design. Today's companies are more knowledgeable of the design process, and that has translated into an openness to unique approaches. As competition increases to make a splash in the annual report market, so has the willingness of businesses to push the design envelope.

To create a meaningful and powerful annual report involves a keen appreciation of both business and audience, strategy and creativity, message and mission. Amy McCarter of Pressley Jacobs Design sums up: "Annual reports are unique in that you need to tell the right story to a very diverse audience. The attitude, tone, and design must all reflect that story."

design
MATT SANDERS
art direction
DAN O'BRIEN
illustration
BRANT DAY, PAUL ZWOLAK
photography
SEAN SULLIVAN,
SCOTT PETERSEN,
KEVIN IRLAY
printing
GEORGE RICE & SONS
firm
MICHAEL PATRICK PARTNERS
client
HAMBRECHT & QUIST

Deploying with Confidence:

Enabling Our Customers' Information Systems
to Operate More Efficiently

Mercury Interactive Corporation

Fort Point Partners

E-BUSINESS TESTING

"Customers of Fort Point like the State of California and Egghead
don't just use the Internet for applications, they rely on it. Because
millions of dollars are at stake, the early identification of performance
and quality issues is paramount to success."

– Matthew Roche, President, Fort Point Partners, Inc.

The emergence of the Internet as an important
new avenue for business has substantially raised
the stakes in software quality. Companies are
opening their information systems literally
through the World Wide Web, inviting people
to access data and buy products; they are taking
IT out of the "back room" and moving it to
the "show room." They are shifting from an
environment of hundreds or even thousands
of users to one where anyone with an Internet
browser can come in and look around.

What they are had better look good. It had
better work. And it had better work flawlessly.

The result is an incredibly dynamic envi-
ronment, where load changes, unpredictably,
by the minute. As complexity and criticality
increase, so does the potential for problems

and errors. There's only one way to ensure
that Web and e-business applications work
well before announcing a URL to the world:
thorough testing. Testing for accuracy, for
reliability, for security and for scalability.

Mercury Interactive has developed automated
testing solutions explicitly for Internet and
e-business applications to improve quality,
performance, security and reliability. Our
testing solutions reduce the risk of exposing
business-critical Internet and intranet systems to
the outside world, allowing developers to deploy
their applications on the biggest computer
network in the world with confidence.

Gap, Inc.

CLIENT/SERVER TESTING

"In today's environment, we simply cannot afford to deliver the
software twice. We have to do it right the first time. I've learned
the hard way and those lessons never leave you. We have to
institute a testing methodology that will deal with these complex
systems we're building."

– Mick Connors, CIO, Gap, Inc. *Application Development Trends, April 1997*

The days when an executive would ask a
"systems analyst" to get a number or run a
report on the computer in the back room are
over. Most modern applications are based on
client/server architecture. Users interact
directly with the software and the network,
when they want to and how they want to.
And that software has to work as people using
it can do their jobs. Which means it must be
thoroughly tested before it is deployed.

For in-house software developers, for systems
integrators, and for independent software
vendors, robust, automated testing tools are a
necessity. And the key word in that sentence is
"automated." Simply letting users have a go at
a new application is not efficient, not rigorous
and not flexible enough to be able to deploy
with confidence.

A suite of testing solutions is required, and
that's what Mercury Interactive offers. Indeed,
we sell the only automated testing solution
that addresses the full range of quality needs:
testing clients, testing servers, testing the Web,
and testing the system as a whole.

We also offer a testing solution designed to
work with the growing Microsoft presence in
enterprise applications. We have the only
complete testing solution for the Windows
NT operating system (including load testing
tools). And we're working with Microsoft
directly to provide testing solutions for their
latest NT, SQL Server and DCOM products.

EIGHT

PATIENTS

TALK

HEARTPORT

ANNUAL REPORT 1997

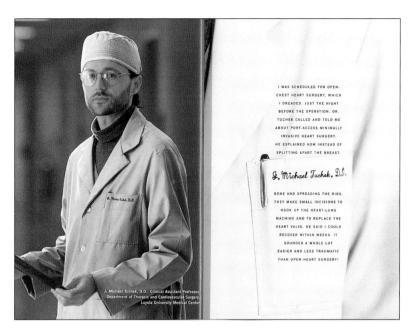

I WAS SCHEDULED FOR OPEN-CHEST HEART SURGERY, WHICH I DREADED. JUST THE NIGHT BEFORE THE OPERATION, DR. TUCHEK CALLED AND TOLD ME ABOUT PORT-ACCESS MINIMALLY INVASIVE HEART SURGERY. HE EXPLAINED HOW INSTEAD OF SPLITTING APART THE BREAST-

J. Michael Tuchek, D.O.

BONE AND SPREADING THE RIBS, THEY MAKE SMALL INCISIONS TO HOOK UP THE HEART-LUNG MACHINE AND TO REPLACE THE HEART VALVE. HE SAID I COULD RECOVER WITHIN WEEKS. IT SOUNDED A WHOLE LOT EASIER AND LESS TRAUMATIC THAN OPEN-HEART SURGERY!

J. Michael Tuchek, D.O., Clinical Assistant Professor, Department of Thoracic and Cardiovascular Surgery, Loyola University Medical Center

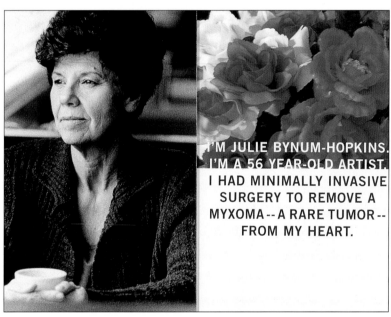

I'M JULIE BYNUM-HOPKINS. I'M A 56 YEAR-OLD ARTIST. I HAD MINIMALLY INVASIVE SURGERY TO REMOVE A MYXOMA -- A RARE TUMOR -- FROM MY HEART.

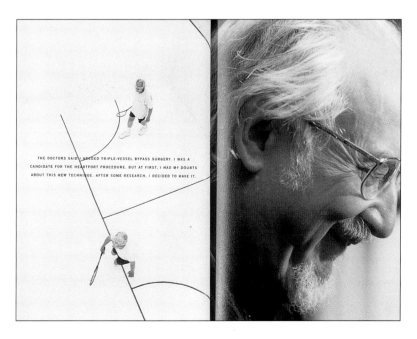

THE DOCTORS SAID I NEEDED TRIPLE-VESSEL BYPASS SURGERY. I WAS A CANDIDATE FOR THE HEARTPORT PROCEDURE. BUT AT FIRST, I HAD MY DOUBTS ABOUT THIS NEW TECHNIQUE. AFTER SOME RESEARCH, I DECIDED TO HAVE IT.

design
KEVIN ROBERSON
art direction
BILL CAHAN
illustration
KEVIN ROBERSON
photography
KEN PROBST
firm
CAHAN & ASSOCIATES
client
HEARTPORT

design
KEVIN ROBERSON
art direction
BILL CAHAN
illustration
KEVIN ROBERSON
firm
CAHAN & ASSOCIATES
client
VIVUS, INC.

CAUTION:
*READING THIS ANNUAL REPORT
MAY CAUSE AN ERECTION*

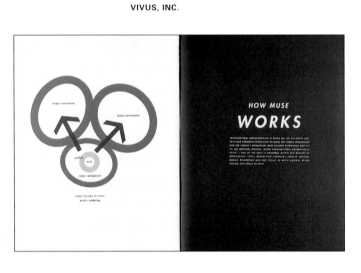

HOW MUSE
WORKS

EXPANSION
TO MEET DEMAND

VIVUS has created high quality facilities to efficiently manufacture MUSE, the first ever micro-suppository delivered in a novel transurethral method.

In our first year of commercial production, more than eight million MUSE systems were manufactured in a 6,000 square foot production facility. Efforts were initiated in mid-1997 to meet market demand by expanding production capacity within a newly leased 90,000 square foot facility. Approval of this new plant to ship product to the United Kingdom was granted by the Medicines Control Agency (MCA) in March of 1998 and regulatory authorization by the FDA is in process. When both facilities are fully operational, VIVUS will have quintupled its production capacity and established a manufacturing operation which includes formulation, filling, packaging, analytical laboratories, storage, distribution and administrative offices.

Also in 1997, VIVUS enhanced its management team, adding Mike Levitt, Vice President of Operations and Carol Karp, Vice President of Regulatory Affairs, to increase the Company's capabilities in large scale pharmaceutical manufacturing.

LOCAL
PROBLEM

LOCAL
SOLUTION

In 1997, VIVUS established MUSE® (alprostadil) in the United States as a first line therapy for treatment of erectile dysfunction. MUSE was launched in January of 1997 and by the end of the year, more than 825,000 prescriptions were written and 8 million units sold, thus establishing MUSE in the United States as a leading treatment for erectile dysfunction by urologists and as one of the top 35 most successful first year pharmaceutical products ever.

Local problem, local solution. Experts agree that for many men erectile dysfunction is a local disorder; consequently, the transurethral delivery of treatment provided by MUSE is a novel, local solution to this local problem. MUSE provides the patient, partner and physician a convenient and minimally invasive treatment which explains, in large part, its rapid acceptance and use in 1997.

Alprostadil safety and efficacy. First licensed as a pharmaceutical in 1981, the safety and efficacy of alprostadil as a therapeutic agent is well established. Experimental intracavernosal injection of alprostadil for the treatment of erectile dysfunction began in the late 1980s and culminated with Food and Drug Administration (FDA) clearance of alprostadil for injection therapy of erectile dysfunction in 1995. VIVUS began clinical trials in 1992, and in five short years, successfully demonstrated that alprostadil also can be delivered safely and effectively via the urethra using a small, plastic applicator rather than a needle.

Novel drug delivery. MUSE uses a novel drug delivery system which consists of a single-use, prefilled plastic applicator designed for easy handling, administration and disposal. The small size of the applicator provides both patient and partner with a discreet and easy-to-use treatment option.

Kowloon-Canton Railway Corporation
Annual Report 1996

design
YU CHI KONG, NG WAI HAN
art direction
KAN TAI-KEUNG, YU CHI KONG
photography
LEONG KA TAI
firm
KAN & LAU DESIGN CONSULTANTS
client
**KOWLOON-CANTON
RAILWAY CORPORATION**

KCR Light Rail

Opportunities for expansion of various parts of the Light Rail network are being explored to meet the ever-increasing demand for public transport within the north-west New Territories.

With its role of serving a number of widely-dispersed conurbations, Light Rail is looking ahead to maximise the revenue potential of planned major housing developments in the Tin Shui Wai landbank. The steady intake of a forecast 120,000 residents to this area, coupled with the completion of some major housing estate projects in Yuen Shui in the coming years, will help us boost population growth, which has slowed down in recent years.

Competition from other forms of transport in the area remains vigorous. Through assiduous marketing and close attention to service standards, however, Light Rail has achieved sustained growth. During the year, patronage grew 2%, and we carried an average of 342,000 passengers each day, and

an additional 18,000 passengers used our feeder buses. Regional market share increased from 69% to 71%, and revenue growth was 11%. The 20 new Light Rail vehicles, which will be delivered from mid 1997, will enable us to strengthen our services further and alleviate crowding situations during rush hours.

As patronage increases, we are always seeking to determine how best we can give our customers a pleasant and safe experience throughout their time with us. In addition to the purchase of 20 new Light Rail vehicles, we have also continued our programme of widening platforms and lengthening platform shelters at major stops. This investment in safety and comfort, when completed in 1999, will also make the system easier for disabled people to use. Installation of customer-friendly digitised announcers and visual display units for route information continued and

As the dominant public transport operator in the north-west New Territories, Light Rail is well positioned to become a major feeder to West Rail upon its completion. Studies are under way for Light Rail extensions to serve the new major population centres planned for Tin Shui Wai, and to establish how best the network could integrate with West Rail. We believe this would help to establish Light Rail's financial viability in the long term.

Light Rail	
Route length	31.75km
Number of stops	57
Number of light rail vehicles	99
Daily hours of operation	18
Minimum headway (minutes)	2
Fleet Years	0.3
Off-peak hours	1.8
Average daily ridership (1996)	336,600
(November 1996)	
Highest daily ridership (1996)	404,500
Service punctuality (1996)	99.9%

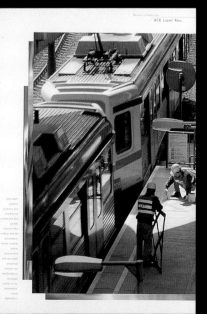

design
**JOYCE NESNADNY,
MICHELLE MOEHLER**
art direction
**MARK SCHWARTZ,
JOYCE NESNADNY**
photography
**RON BAXTER SMITH,
DESIGN PHOTOGRAPHY, INC.**
firm
NESNADNY + SCHWARTZ
client
**THE PROGRESSIVE
CORPORATION**

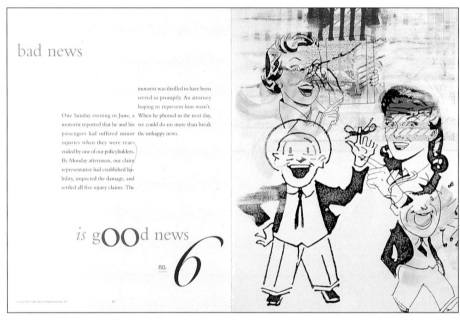

bad news

One Sunday evening in June, a motorist reported that he and his passengers had suffered minor injuries when they were rear-ended by one of our policyholders. By Monday afternoon, our claim representative had established liability, inspected the damage, and settled all five injury claims. The motorist was thrilled to have been served so promptly. An attorney hoping to represent him wasn't. When he phoned us the next day, we could do no more than break the unhappy news.

is gOOd news
no. 6

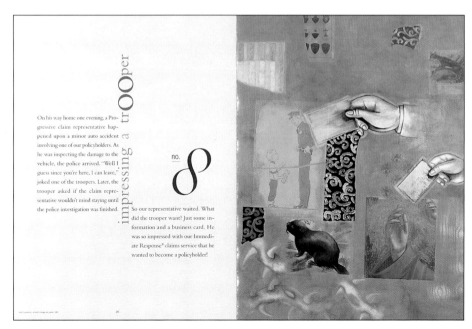

impressing a trOOper

On his way home one evening, a Progressive claim representative happened upon a minor auto accident involving one of our policyholders. As he was inspecting the damage to the vehicle, the police arrived. "Well I guess since you're here, I can leave," joked one of the troopers. Later, the trooper asked if the claim representative wouldn't mind staying until the police investigation was finished.

no. 8

So our representative waited. What did the trooper want? Just some information and a business card. He was so impressed with our Immediate Response® claims service that he wanted to become a policyholder!

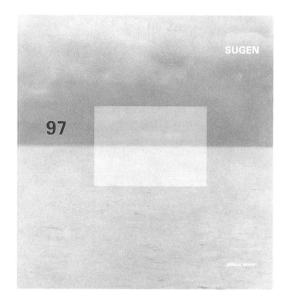

SUGEN

97

ANNUAL REPORT

design
SHARRIE BROOKS
art direction
BILL CAHAN
photography
ROBERT SCHLATTER
firm
CAHAN & ASSOCIATES
client
SUGEN, INC.

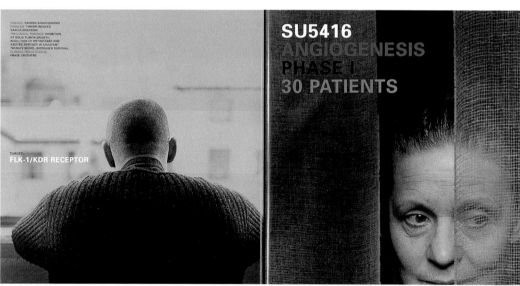

DISEASE: **CANCER/ANGIOGENESIS**
PROBLEM: **TUMOR-INDUCED VASCULARIZATION**
PRECLINICAL FINDINGS: **INHIBITION OF SOLID TUMOR GROWTH, REDUCTION OF METASTASES AND ASCITES; EFFICACY IN ADJUVANT THERAPY MODEL; INCREASED SURVIVAL.**
CLINICAL TRIALS STATUS:
PHASE I INITIATED

TARGET:
FLK-1/KDR RECEPTOR

SU5416
ANGIOGENESIS
PHASE I
30 PATIENTS

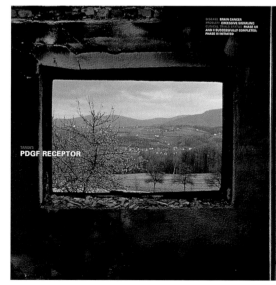

TARGET:
PDGF RECEPTOR

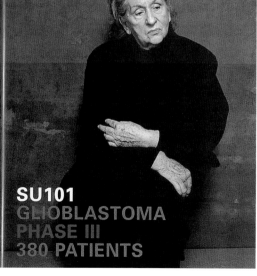

DISEASE: **BRAIN CANCER**
PROBLEM: **EXCESSIVE SIGNALING**
CLINICAL TRIALS STATUS: **PHASE I AND II SUCCESSFULLY COMPLETED; PHASE III INITIATED**

SU101
GLIOBLASTOMA
PHASE III
380 PATIENTS

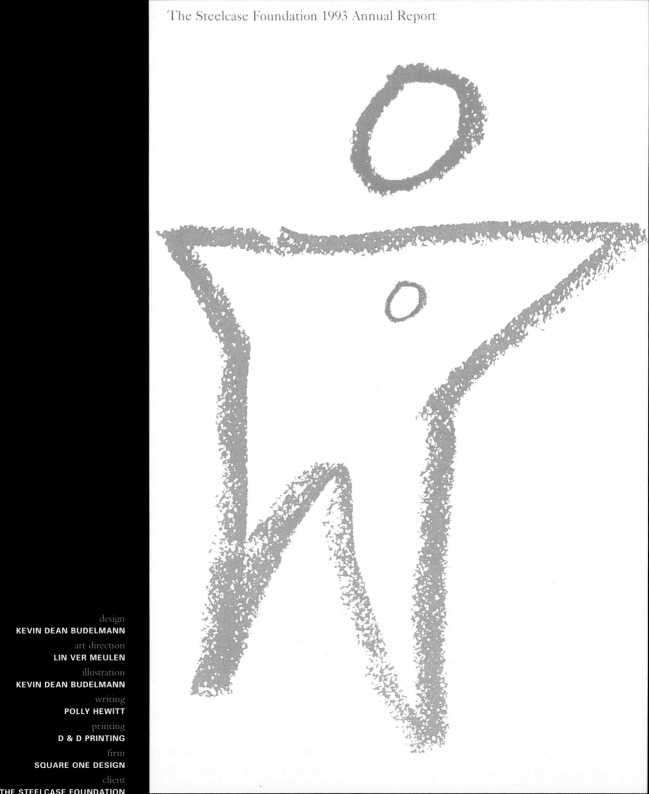

design
KEVIN DEAN BUDELMANN

art direction
LIN VER MEULEN

illustration
KEVIN DEAN BUDELMANN

writing
POLLY HEWITT

printing
D & D PRINTING

firm
SQUARE ONE DESIGN

client
THE STEELCASE FOUNDATION

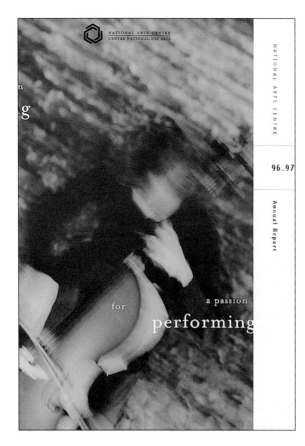

design
MARIO L'ÉCUYER
art direction
JEAN-LUC DENAT
photography
NATIONAL ARTS CENTRE
electronic artwork
MARIO L'ÉCUYER,
MARY KOCH
firm
IRIDIUM MARKETING & DESIGN
client
NATIONAL ARTS CENTRE

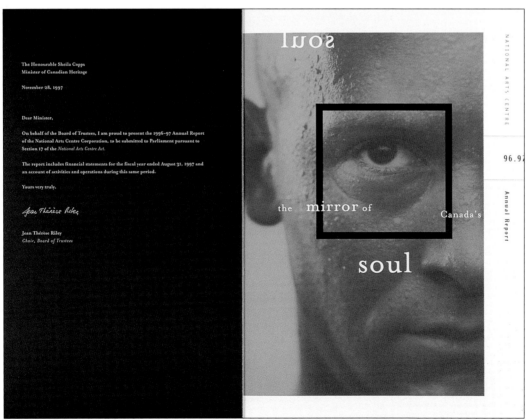

FEELS DIFFERENT, DOESN'T IT?

CADENCE 1996 ANNUAL REPORT

design
BOB DINETZ
art direction
BILL CAHAN
illustration
MARK TODD,
RICCARDO VECCHIO,
JASON HOLLEY,
BOB DINETZ
photography
TONY STROMBERG,
AMY GUIP
firm
CAHAN & ASSOCIATES
client
CADENCE DESIGN
SYSTEMS, INC.

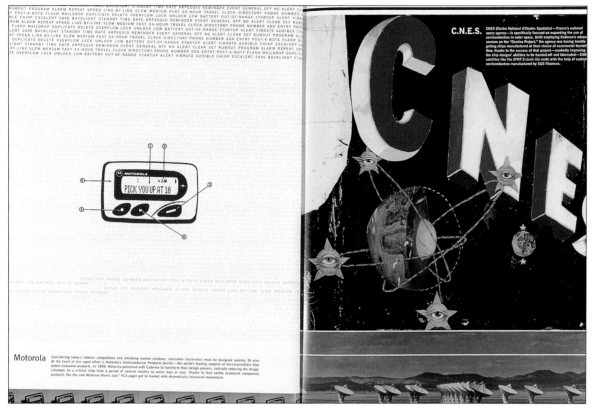

C.N.E.S. CNES (Centre National d'Etudes Spatiales)—France's national space agency—is specifically focused on expanding the use of semiconductors in outer space. Until employing Cadence's advanced services on the "Ocarina Project," the agency was having trouble getting chips manufactured at their choice of commercial foundries. Now, thanks to the success of that project—markedly improving the chip designs' abilities to be handed-off and fabricated—CNES satellites like the *SPOT 5* circle the earth with the help of custom semiconductors manufactured by SGS-Thomson.

Motorola Considering today's intense competition and shrinking market windows, consumer electronics must be designed quickly. Or else. At the heart of this rapid effort is Motorola's Semiconductor Products Sector—the world's leading supplier of microcontrollers that power consumer products. In 1996, Motorola partnered with Cadence to transform their design process, radically reducing the design schedule on a critical chip from a period of several months to seven days or less. Thanks to that swiftly produced component, products like the new Motorola Memo Jazz™ FLX pager get to market with dramatically increased momentum.

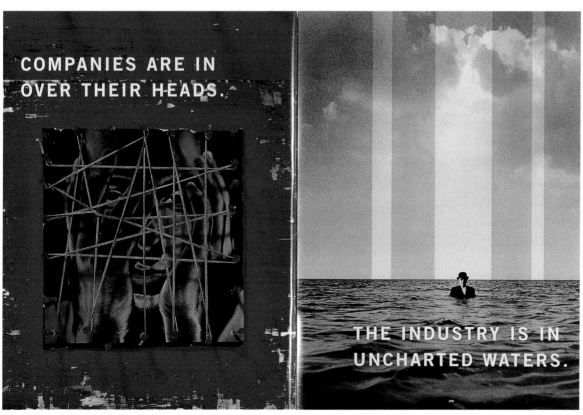

COMPANIES ARE IN
OVER THEIR HEADS.

THE INDUSTRY IS IN
UNCHARTED WATERS.

design
**MATT SANDERS,
ROBERT WONG**
art direction
DAN O'BRIEN
photography
JOHN CASADO
printing
GAC
firm
MICHAEL PATRICK PARTNERS
client
CIDCO, INC.

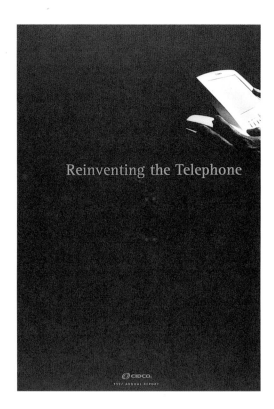

Reinventing the Telephone

AccessoryProducts

SmartPhones

InternetSolutions

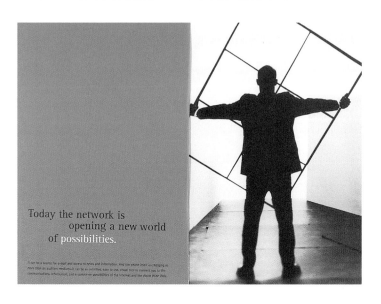

Today the network is
opening a new world
of possibilities.

GaSonics

GaSonics International is
positioned to outpace
market growth.

As semiconductor manufacturing capacity
once again increases, GaSonics
International is ready to leverage its
strong customer relationships and
technology leadership.

With its platform / process
technologies and
business systems in place,
GaSonics International
continues to lead the
market for Integrated Clean
solutions between etch
and deposition.

GaSonics International
helps semiconductor
manufacturers achieve
fundamental goals: higher
yield, higher throughput,
reduced environmental
impact and lower cost
per wafer.

The fundamental
benefits of
Integrated Clean.

c y t e

Cost Yield Throughput Environmental Impact

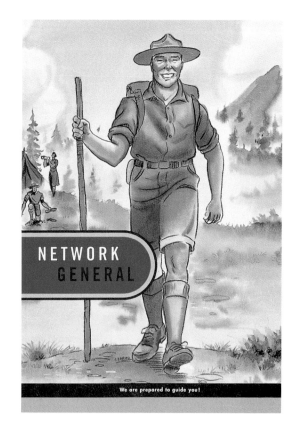

FINDING YOUR WAY

Be prepared. It's important to be prepared when traveling through unfamiliar territory. Finding your way can be difficult when the terrain is complex. Having the right equipment is vital to ensure safe travel, and a quick recovery if you ever stray off the trail.

Network professionals need to be prepared today more than ever. Downtime has significant bottom-line ramifications, and network professionals need to always be thinking ahead, anticipating and preventing problems before they occur. In the world of networking, no one practices this proactive approach to network management like Network General.

At Network General, we are committed to providing customers with the most complete insight possible into their

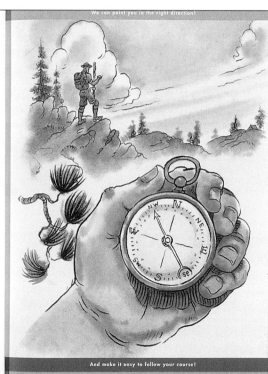

98

X

design
MICHAEL BRALEY

art direction
BILL CAHAN

firm
CAHAN & ASSOCIATES

client
XILINX

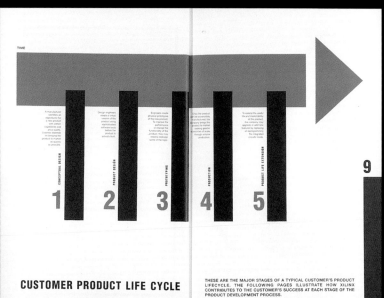

TIME

A manufacturer identifies an opportunity for a new product with certain capabilities and price points. Success depends on designing the product to market as quickly as possible.

CONCEPTUAL DESIGN

Design engineers create a virtual version of the product using sophisticated software tools before the product is actually built.

PRODUCT DESIGN

Engineers create physical prototypes of this new product. To improve the performance or change the functionality of the product, they may need to redesign some of the logic.

PROTOTYPE

Once the product can be successfully manufactured, the company brings the product to market seeking greater economies of scale through volume production.

PRODUCTION

To extend the useful life and marketability of the product, the company may upgrade or add new features by replacing the devices or reprogramming the integrated circuits inside.

PRODUCT LIFE EXTENSION

1 2 3 4 5

9

CUSTOMER PRODUCT LIFE CYCLE

THESE ARE THE MAJOR STAGES OF A TYPICAL CUSTOMER'S PRODUCT LIFECYCLE. THE FOLLOWING PAGES ILLUSTRATE HOW XILINX CONTRIBUTES TO THE CUSTOMER'S SUCCESS AT EACH STAGE OF THE PRODUCT DEVELOPMENT PROCESS.

19

5

PRODUCT FEATURES AND CAPABILITIES

BECAUSE XILINX KEEPS INCREASING THE SPEED AND DENSITY OF PROGRAMMABLE LOGIC DEVICES, XILINX CUSTOMERS CAN EXTEND THE LIFE OF THEIR PRODUCTS AND EARN A HIGHER RETURN ON THEIR DEVELOPMENT INVESTMENT BY REPLACING THE ORIGINAL DEVICES WITH FASTER, DENSER, AND LESS EXPENSIVE VERSIONS. CUSTOMERS REALIZE THE FULL VALUE OF WORKING WITH XILINX, AND PLAN FUTURE PRODUCTS USING XILINX DEVICES, SOFTWARE, AND SUPPORT.

Age 14

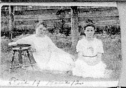

Elsie and Marie
in 1913.

Frank was a
pioneer in the
frozen food
industry.

GERON
97

Elsie carefully selected
the flowers she planted
in her garden.

Age 75

ELIZABETH "ELSIE" OLIVER was born May 1, 1899 in Dahlhausen, Germany. She came to Washington
state on a clipper ship with her parents and three brothers at age 1. Elsie's sister Marie
was born a year later.

The family moved to California in 1916 and Elsie graduated valedictorian of her high school
class in 1918. In 1922 she married Frank Oliver, a Stanford student from Watsonville.

Elsie loved to cook. No one passed through her kitchen without eating. She would say "food
fuels the brain, so eat!" Always a generous, giving spirit, Elsie never stopped helping any
and all in need of food or clothing or compassion. Elsie was widowed at age 87 after 65
years of marriage. She was still quite active and full of life and enjoyed living alone in
her home of 70 years. She got RRk pleasure from gardening, writing letters and having friends
over for a game of cards.

((she had a talent with words))

Witty and wise to the end, Elsie died this past December. She was 97. For those who might
not live a disease-free life, Geron is pursuing treatments that will allow people to remain
healthy as they age.

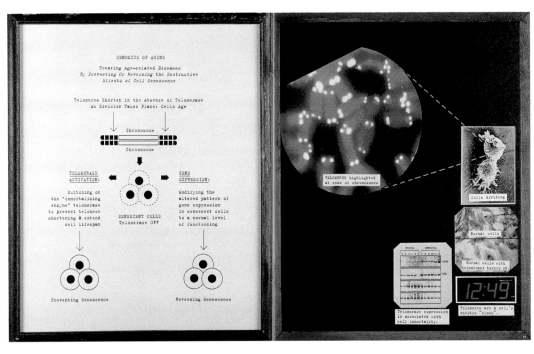

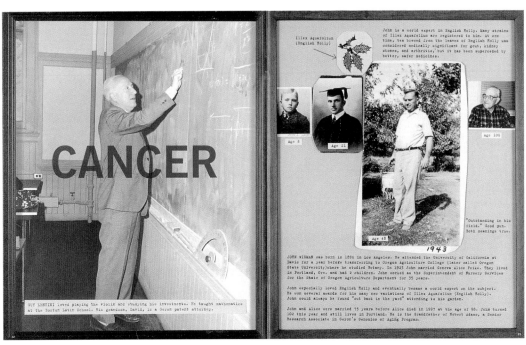

design
BOB DINETZ

art direction
BILL CAHAN

illustration
BOB DINETZ

photography
TONY STROMBERG

firm
CAHAN & ASSOCIATES

client
GERON CORPORATION

design
AMY MCCARTER
art direction
AMY MCCARTER
firm
PRESSLEY JACOBS DESIGN
client
PLATINUM ENTERTAINMENT

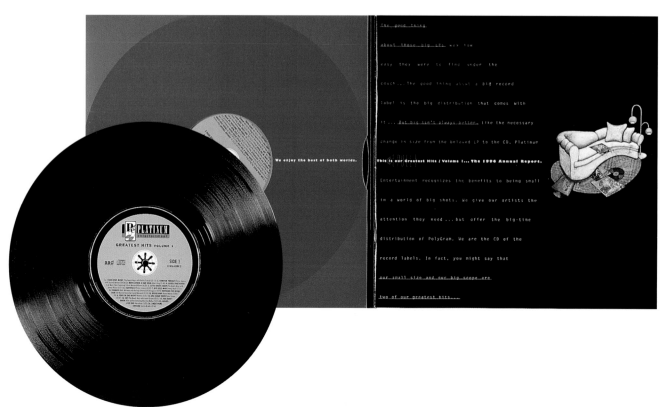

"Behind every word."

ERICSSON

design
CORNWELL DESIGN PTY LTD
art direction
STEVEN CORNWELL
firm
CORNWELL DESIGN PTY LTD
client
ERICSSON AUSTRALIA

Depend on us

We're behind **every word.**

design
AMY MCCARTER
art direction
AMY MCCARTER
photography
KEVIN ANDERSON
firm
PRESSLEY JACOBS DESIGN
client
PLATINUM TECHNOLOGY

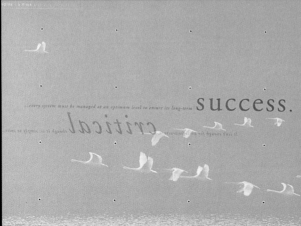

the battle.

After the battle...

We're prepared better than ever before to continue with our story. The fight's never over...

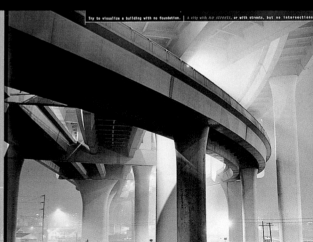

success.

critical

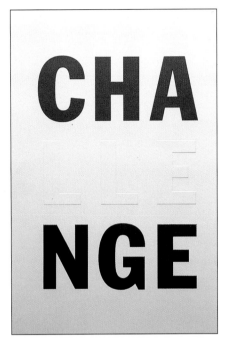

CHA
NGE

design
**STEVEN SIKORA,
RICHARD BOYNTON**
art direction
STEVEN SIKORA
firm
DESIGN GUYS
client
PUBLIC RADIO INTERNATIONAL

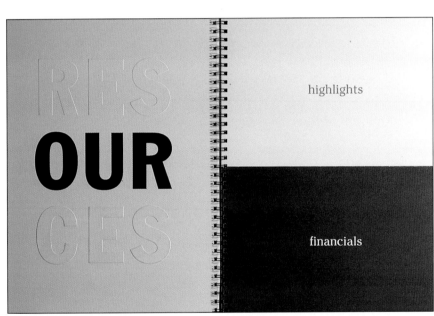

highlights

OUR

financials

A FUNDING CRISIS

IN THE EFFORT TO COME TO GRIPS WITH THE FEDERAL BUDGET DEFICIT THIS
PAST YEAR, MEMBERS OF CONGRESS SCRUTINIZED PUBLIC BROADCASTING. THE
ANNUAL APPROPRIATION FOR PUBLIC TELEVISION AND RADIO, THOUGH FAR
SMALLER THAN THE COST OF A SINGLE SEAWOLF SUBMARINE, NONETHELESS WAS
ONE OF THE MOST HOTLY DEBATED BUDGET ITEMS.

Public attention to this debate brought forth
an unprecedented outpouring of support for
public broadcasting. According to a USA
TODAY/CNN/Gallup Survey, 76% of American
citizens favor ongoing support for public
radio and television. In importance to
American taxpayers, poll after poll showed
public broadcasting ranked near the top,
right behind support for the armed forces.

Though heartened by this groundswell of
support, we at PRI concluded future plans
cannot assume growing or even level federal
appropriations. Moreover, changes in the
federal budget will also increase pressures
on state government and public universities
to limit discretionary spending, possibly
affecting the support received by many public
radio stations. In this climate, public radio
will need to strengthen its appeal to indi-
viduals, corporations, and foundations. To
succeed, we must declare our mission in
clear and compelling terms, and demon-
strate powerfully the difference we make
with the resources we receive.

PRI was formed to broaden the range of
talents, sources, and perspectives available
to radio listeners nationwide. In adopting a
new mission statement in 1993, we tightened
our focus on developing programming that
prepares Americans for an increasingly
diverse, challenging, and highly interdepen-
dent world. At the same time, PRI broadened
its operating stance, defining itself hence-
forth as a radio *publisher*. Playing at different
times the roles of marketer, distributor,
investor, and co-producer, PRI ensures that
the greatest possible value is obtained from
resources committed to the creation of
content. To serve growing audiences better,
PRI has embraced, and will help its affiliates
master, technologies that enhance sound
quality and permit listeners to interact with
program material and with each other. To
remain true to our purpose while sustaining
the enterprise, PRI will even more vigorously
adopt the role of change agent within the
field of public service broadcasting, leading
the way toward a public radio system able to
flourish in an era of reduced federal support.

Doing more with less.

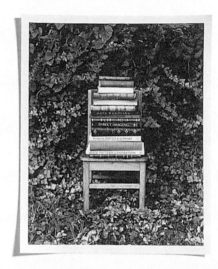

ETEC SYSTEMS

1997

ANNUAL REPORT

design
LIAN NG
art direction
BILL CAHAN
photography
FREDRIK BRODEN
firm
CAHAN & ASSOCIATES
client
ETEC SYSTEMS, INC.

THE
INDUSTRY
is CHANGING

THE SEMICONDUCTOR INDUSTRY,

DRIVEN BY MOORE'S LAW AND ITS DEMANDS

FOR INCREASING DATA COMPRESSED INTO EVER SMALLER SPACES,

IS IN A CONSTANT STATE OF EVOLUTION

AND CHANGE.

441717 247749

design
JIM ALLSOPP

art direction
JEFF DAVIS

creative direction
TOR PETTERSEN

photography
NICK READ
BOB FYFFE
DEREK RICHARDS
JON WYAND

firm
TOR PETTERSEN & PARTNERS LTD

client
KINGFISHER PLC

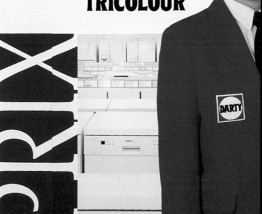

design
NICK KENDALL, JIM ALLSOPP, SIMON COUCHMAN

art direction
JEFF DAVIS, DAVID BROWN, CRAIG JOHNSON

creative direction
TOR PETTERSEN

firm
TOR PETTERSEN & PARTNERS LTD

client
PRICE WATERHOUSE

FROM TODAY YOU ARE PART OF A DIFFERENT ORGANISATION

STRONGER TOGETHER

The combination marks the beginning of a new era for Price Waterhouse — one of even greater co-operation between the US and Europe, and indeed among all the firms in the Price Waterhouse global network. From now on we will make strategic decisions and take related actions together, rather than as separate firms. Like many of our global clients, **we are empowering our business units** — in our case, the service lines and market sectors — to work across all our territories. A combination-wide strategy means that the identification and targeting of priority companies, staffing decisions on client assignments, and investment in new products, services, training, and IT will no longer be restricted by geographical boundaries.

The driving force behind this combination is the market. Both existing and future clients will benefit from a PW which now has **a bigger pool of specialists** to mobilise for international assignments. They will also benefit because our people are now working under co-ordinated management, using consistent methodologies.

Internally, the prospects are just as bright. While the world may not look very different today, over the long term the combination will provide many more opportunities — opportunities to work on **cross-border assignments, to travel and learn about other cultures,** to meet people with diverse backgrounds and perspectives, and to develop global business expertise. It will foster a spirit of global teamwork that will pay off not only in greater client satisfaction, but also greater career satisfaction. As we grow, increase earnings, enter new lines of business, and serve more and more top-tier companies, there is no question that the combination will **open up career opportunities** for staff throughout the Price Waterhouse world.

But the combination will not only benefit US and European clients and staff. PW firms throughout the world will share in the growth opportunities that this move will create. PWE and the US together represent three-quarters of the worldwide revenues of all PW firms. A stronger PW means **a stronger global PW,** able to increase investments in emerging markets and to deploy more resources to locations outside our own territories.

We must always remember that clients do not hire "PW France", "PW US", or "PW Europe" — they hire Price Waterhouse. That is how we must think of ourselves and how we must behave: as **one global force united in our commitment to clients and to achieving the World Ambition.** Over the coming months, the combination will start to grow as other PW firms join us. Other firms in our global network may opt for alternative ways to **strengthen the global brand of Price Waterhouse.** But whichever route our individual firms take, the Price Waterhouse world will continue to be highly integrated, bound by our common history, culture, values, and dedicated people.

Jermyn Brooks (Chairman) Jim Schiro (CEO)

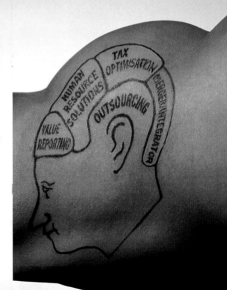

The MIND & MUSCLE to SUCCEED

Today's most successful companies are focusing increasingly on product development cycles. The trends are clear: quicker development from drawing board to delivery, tailored products which meet customer needs, and the ability to deliver simultaneously anywhere in the world.

In this respect PW is no different. We need to develop initiatives which leverage the expertise of all our service lines and can be launched seamlessly across the combination and beyond. Below are some of our most recent developments, none of which could have been conceived or delivered globally by a single PW firm acting alone.

Business Process Outsourcing Our newest service line began life on the drawing board just a year or so ago, and is exploiting a market of $10 billion which is forecast to grow fourfold by the year 2000. The growing importance of outsourcing can be clearly seen in the work PW is doing for BP. This top-tier client's competitive advantage comes from finding and distributing oil — that's what it is good at, and where it wants to be "best in class". It can't be best in class at everything, so it's looking to outsource almost everything else it does to world-class suppliers. We have supplied outsourcing services in internal audit and tax compliance for years, but Business Process Outsourcing (BPO) takes us up the value line, controlling some, or even all, the support services used by a business. PW adds value by bringing together a full range of highly-skilled professionals on a worldwide basis. The combination — and indeed full global co-operation — is vital to maximising the value of our BPO service. **Merger Integrator** "Most mergers fail to create value for shareholders. Managers underestimate the complexity of corporate marriage," says The Economist. A PW Merger Integrator team is being drawn together from both sides of the Atlantic and from all the service lines. It will bring to

market an integrated "suite" of merger-related services, that will help clients capture the full benefits of merging. **Global Tax Optimisation** Increasingly, multinational companies are becoming truly global — and must re-examine their tax strategies to reduce their overall effective global tax rate. The savings can run into many millions. PW, by combining its international tax skills with its Change Integration capabilities, will provide top-tier companies with a comprehensive programme for developing and implementing global tax strategies that achieve permanent tax savings — and significantly increase shareholder value as a result. **Value Reporting** PW has pioneered services in this area, and companies around the world are now talking the ValueBuilder language. A high priority for thought leadership within the combination will be to develop our efforts into an integrated product offering called Value Reporting (VR). Where traditional accounting and reporting looks at past performance, VR looks at long-term potential for cash generation and growth, and integrates external market assessments of a company's performance with its own internal reporting. **Global Human Resource Solutions** PW, like other leading global organisations, attaches immense importance to its "human capital". Mastering the full spectrum of human resource issues is vital to the success of global companies. PW professionals representing every discipline will work together to provide a wide range of HR consulting services.

These products and services demonstrate PW's combined ability to cross the divide between strategy and implementation, between helping clients shape their direction and helping them reach their goals: in short, our ability to provide both Mind & Muscle.

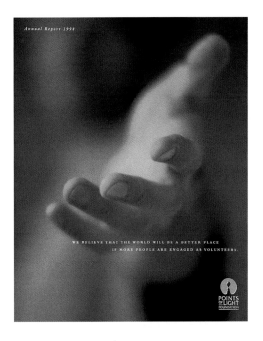

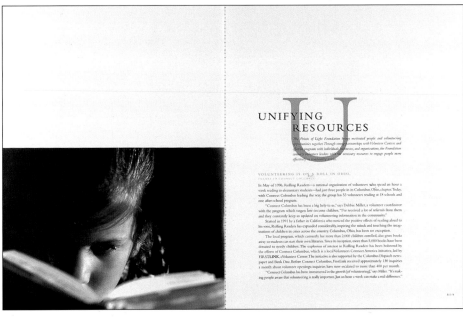

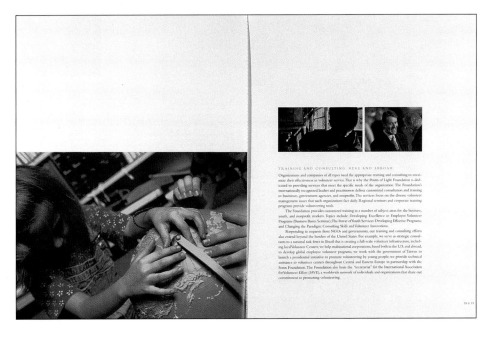

design
PUM MEK-AROONREUNG

writing
STEPHEN SMITH

art direction
SUPON PHORNIRUNLIT

firm
SUPON DESIGN GROUP

client
POINTS OF LIGHT FOUNDATION

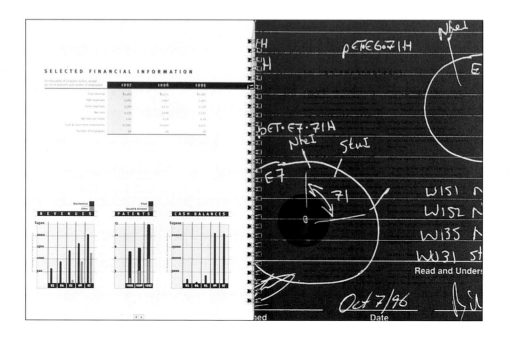

design
JIM ALLSOPP
art direction
JEFF DAVIS
creative direction
TOR PETTERSEN
firm
TOR PETTERSEN & PARTNERS LTD
client
THE EMI GROUP PLC

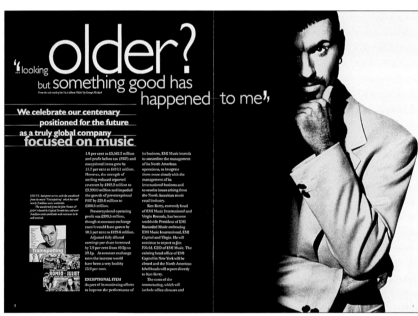

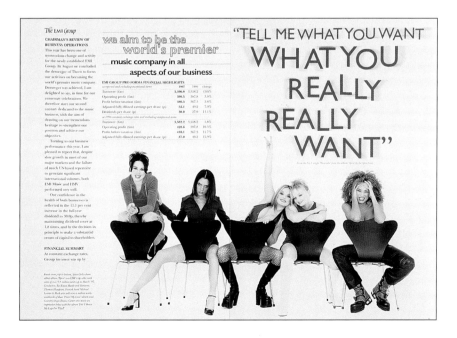

ECOLOGY

BREAKING THE RULES IN PUBLICATION DESIGN

broch

RRRRRRR

> A work should contain its total meaning within itself and should impress it on the spectator before he even knows the subject.
>
> —Henri Matisse

WE HAVE SEEN THE FUTURE OF DESIGN AND IT'S NOT A PRETTY PICTURE

Once a throw-away piece with fleeting appeal, today's brochures are enduring communications pieces for businesses and products alike. They are pivotal for a company to express meaning and communicate its core message.

As designer Kevin Roberson of Cahan and Associates points out, "Companies are looking to do a little more from a marketing and public relations stand-point. And they're doing that through pieces like the main corporate brochure."

The brochure's physical attributes are key. Its tangibility makes it a fixture for conveying lasting ideas and well-defined corporate philosophy. That the reader can touch a brochure and absorb its visuals immediately makes it a ripe medium for crystallizing an idea quickly and coherently.

"What makes a brochure special is its direct, personal relationship with the viewer," says Lewis Moberly, a London-based designer. "It is held in the hand, paced from cover to cover and should hold the attention and interest of the reader."

Brochures can be customized for a variety of purposes and boast a rare versatility in the business world: They illustrate capabilities, articulate messages, recruit employees, and perform countless other functions. "The brochure has a specific and captive audience," says Moberly. "It has many roles—as a corporate tool or sales tool or an information piece. It can be consumer- or trade-oriented."

Like many publications, brochures rely heavily on copy to drive visual solutions. "Both text and images have to work in unison," declares Moberly.

But is new media taking the place of brochures? With "check out our web site" the catchphrase of the moment, it seems that companies and products are placing less reliance on brochures to communicate their messages. However, according to Roberson, brochures are now being used in concert with, rather than in competition to, Web sites. "The brochure should tie into the brand personality, especially in its Web presence and advertising."

Clearly, given their tangible quality and versatility, brochures are here to stay. But are the design rules changing? Yes and no. According to Moberly, certain format guidelines and communicative imperatives are fixed, but there is room for experimentation. "There are well-founded rules with regard to layout and grid systems. But rules are meant to be challenged."

f current workplace speak, concepts
Hot-Desking, Harboring, Free-Address
ave real meaning and are here to stay.
ion, personalisation of space and customised
only a few of the potential benefits. Ensuring
e meets the rigorous demands of such dynamic
en a priority design objective for Schiavello.

design
CORNWELL DESIGN PTY LTD
art direction
STEVEN CORNWELL
firm
CORNWELL DESIGN PTY LTD
client
SCHIAVELLO

design
CHUNG YEW KEE, RANEE GOH

creative direction
ERICA WONG

photography
PETER CHEN, JOE AIK

writing
KRISTY STEEL

firm
ASSOCIATES IN DESIGN

client
LEGACY (SIGLAP) PTE LTD

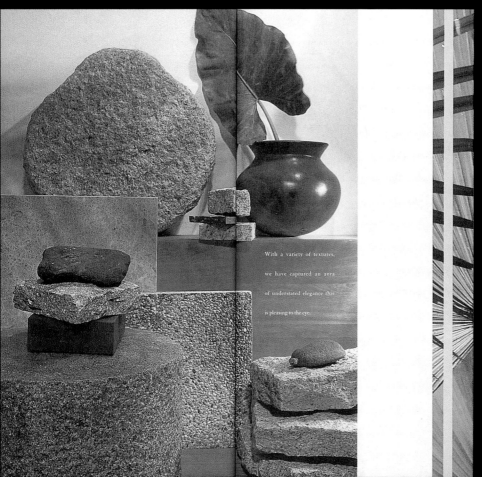

With a variety of textures,
we have captured an aura
of understated elegance that
is pleasing to the eye.

design
DOREEN CALDERA
art direction
**DOREEN CALDERA,
PAUL CALDERA**
photography
BOB CAREY
firm
CALDERA DESIGN
client
CALDERA DESIGN

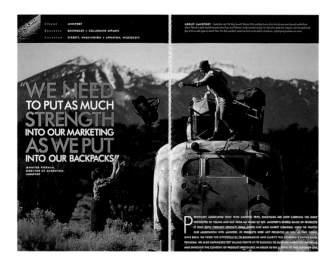

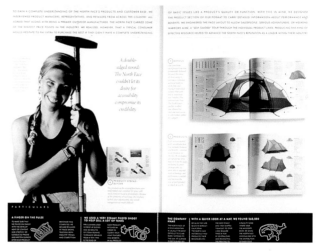

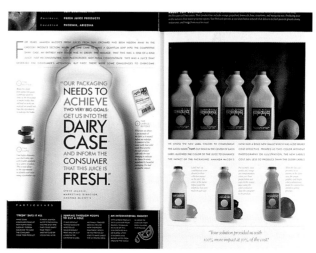

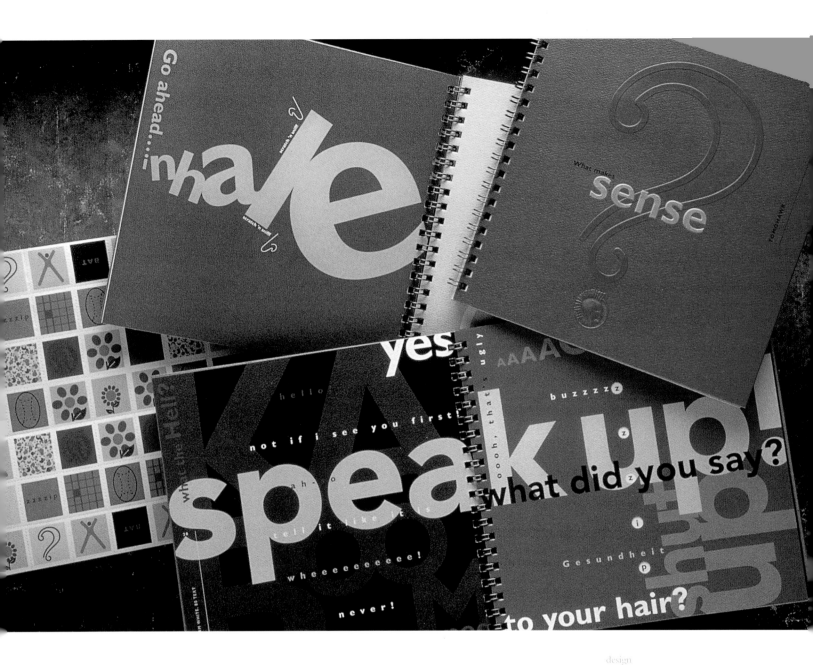

design
JACK ANDERSON, LISA CERVENY,
MARY HERMES, JANA NISHI,
JANA WILSON ESSER, VIRGINIA LE
art direction
JACK ANDERSON, LISA CERVENY
illustration
DAVE JULIAN
photography
TOM COLLICOTT
firm
HORNALL ANDERSON
DESIGN WORKS
client
MOHAWK PAPER MILLS

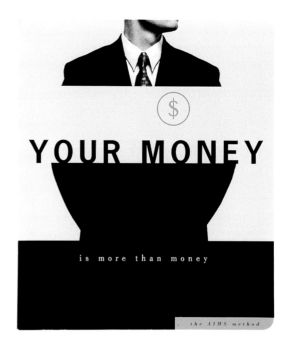

design
JEFF DEY
art direction
JEFF DEY
photography
SCOTT HUNT
firm
BRAINSTORM
client
AIMS

YOUR MONEY

is more than money

the AIMS method

When you've reached the point you are ready to sell your business, you want to get the most value possible. After all, your money is more than money. It is a measurement of your success. It's a reward for years of hard work, long hours and determination. You deserve to keep as much of your money as possible. That's why the AIMS Method makes so much sense. Why not treat your money in the best way available?

Your Money Is A Measurement

You spend years establishing a business to make it successful. It takes long hours, hard work, and, sometimes, nerves of steel. Over time, you build value in your company. Finally you can measure your success in dollars and cents.

Once money is a measurement of your success, you may find you want to change directions. Perhaps you're reached an age where you want to retire. Or you're tired of the long hours. Or maybe you want an equity position in a larger company. There are all sorts of reasons you might want to sell your company, but you hold off, because of the tax burden you face. Who would want to turn over 40 to 50 percent of the monetary value of their life's work to the government? Meanwhile the opportunity to sell may pass.

With the AIMS Method, you can sell your business and reap the benefits of your labor. As you'll see on the following pages, the AIMS Method creates a win-win situation for buyers and sellers through the creative integration and application of IRS tax code sections and revenue rulings.

Your Money Should Be A Growing Investment

Assume you invest one million dollars of your sale proceeds into an account that earns a ten percent annual return for 20 years. The proceeds and the growth on this account are taxed at 40 percent. At the end of year 20, your investment will be worth less than $2,000,000.

Now, assume investing that same million dollars of your sale proceeds into an account that earns a ten percent annual return for 20 years. If the proceeds and the growth on this account are not taxable, your investment will grow to be worth over $7,300,000 at the end of year 20.

A critical factor in accumulating wealth is taxation. Without taxes, investments can grow more efficiently.

The way you are paid when you sell your business is important.

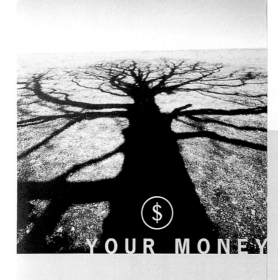

$ YOUR MONEY

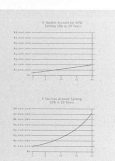

ProBusiness
PAYROLL TAX SERVICES

design
BENJAMIN PHAM

art direction
BILL CAHAN

photography
GALLEN MEI

illustration
BENJAMIN PHAM

firm
CAHAN & ASSOCIATES

client
PROBUSINESS

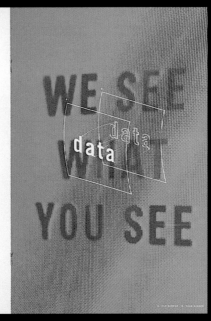

WE SEE WHAT YOU SEE

data

FEATURES AND BENEFITS

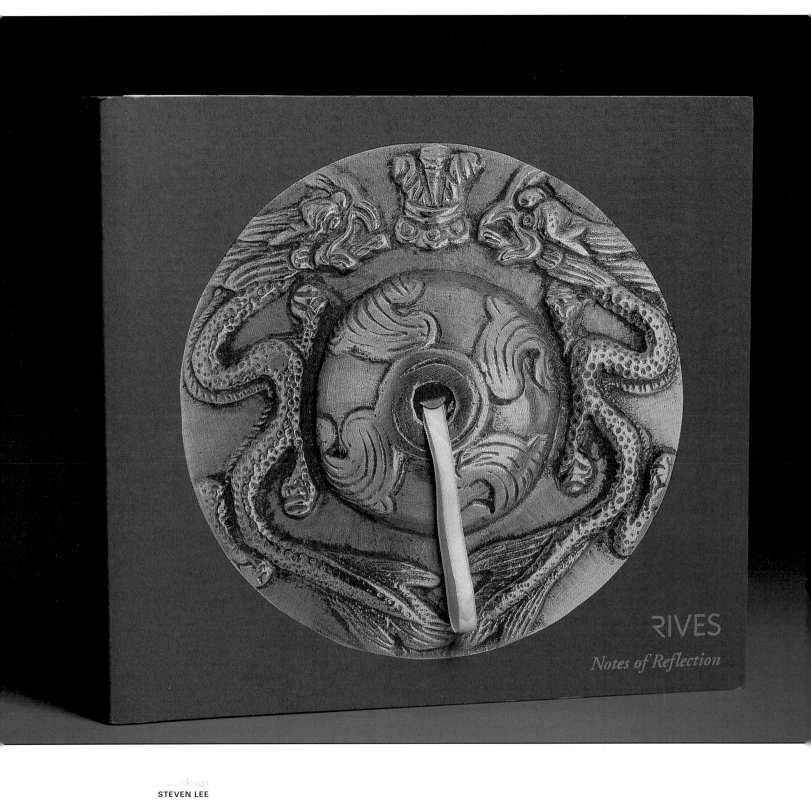

RIVES

Notes of Reflection

design
STEVEN LEE
creative direction
TAN BENG SENG
firm
THE BLUE TANGERINE GROUP
client
RIVES PAPER

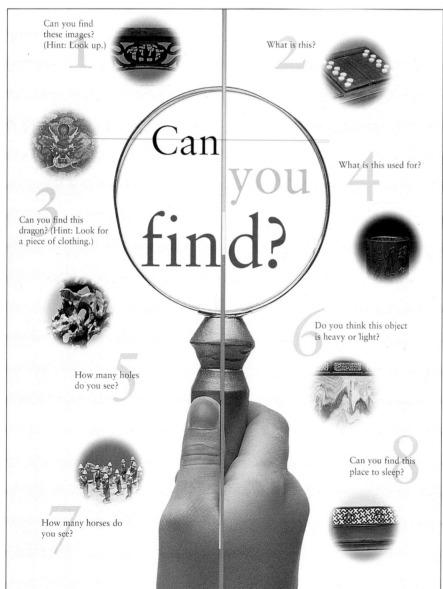

design
MARK WAGNER, PEPA REIMANN
art direction
TODD NESSER
creative direction
RICHELLE HUFF
photography
**THE MINNEAPOLIS
INSTITUTE OF ARTS**
project management
DIANA GRAHAM
senior production
PAM BORGMAN
firm
LARSEN DESIGN + INTERACTIVE
client
**THE MINNEAPOLIS
INSTITUTE OF ARTS**

design
BRYAN CLARK, ANN MARSHALL
art direction
MARY LEWIS
firm
LEWIS MOBERLY
writing
MARTIN FIRRELL
client
**NOVARTIS CONSUMER
HEALTH PHARMACEUTICALS**

40

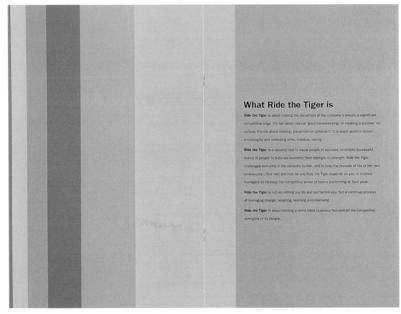

What Ride the Tiger is

Ride the Tiger is about making the dynamism of the company's people a significant competitive edge. It's not about clerical 'good housekeeping' or creating a punitive 'no' culture; it's not about policing, prevention or constraint. It is about positive action, encouraging and rewarding drive, impetus, daring.

Ride the Tiger is a dynamic tool to equip people to succeed, to enable successful teams of people to build our business from strength to strength. Ride the Tiger challenges everyone in the company to risk, and to reap the rewards of his or her own endeavours – how well and how far you Ride the Tiger depends on you. It enables managers to harness the competitive power of teams performing at their peak.

Ride the Tiger is not something you do and put behind you, but a continual process of managing change, adapting, learning and improving.

Ride the Tiger is about building a world class business founded on the competitive strengths of its people.

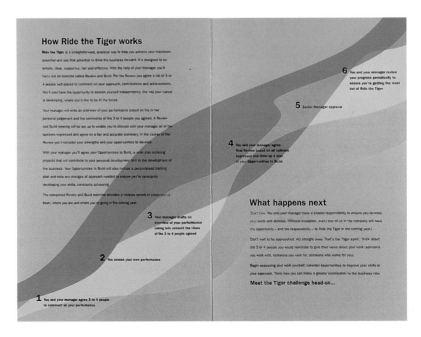

How Ride the Tiger works

Ride the Tiger is a straightforward, practical way to help you achieve your maximum potential and use that potential to drive the business forward. It's designed to be simple, clear, supportive, fair and effective. With the help of your manager you'll carry out an exercise called Review and Build. For the Review you agree a list of 3 or 4 people well placed to comment on your approach, contributions and achievements. You'll also have the opportunity to assess yourself independently, the way your career is developing, where you'd like to be in the future.

Your manager will write an overview of your performance based on his or her personal judgement and the comments of the 3 or 4 people you agreed. A Review and Build meeting will be set up to enable you to discuss with your manager all of the opinions expressed and agree on a fair and accurate summary. In the course of the Review you'll consider your strengths and your opportunities to develop.

With your manager you'll agree your Opportunities to Build, a work plan outlining projects that will contribute to your personal development and to the development of the business. Your Opportunities to Build will also include a personalised training plan and note any changes of approach needed to ensure you're constantly developing your skills, constantly advancing.

The completed Review and Build exercise provides a concise record of where you've been, where you are and where you're going in the coming year.

1 You and your manager agree 3 to 4 people to comment on your performance

2 You assess your own performance

3 Your manager drafts an overview of your performance taking into account the views of the 3 to 4 people agreed

4 You and your manager agree final Review based on all opinions expressed and draw up a plan of your Opportunities to Build

5 Senior Manager approval

6 You and your manager review your progress periodically to ensure you're getting the most out of Ride the Tiger

What happens next

Start now. You and your manager have a shared responsibility to ensure you develop your skills and abilities. (Without exception, every one of us in the company will have the opportunity – and the responsibility – to Ride the Tiger in the coming year.)

Don't wait to be approached. Act straight away. That's the 'Tiger spirit'. Think about the 3 or 4 people you would nominate to give their views about your work (someone you work with, someone you work for, someone who works for you).

Begin assessing your work yourself: consider opportunities to improve your skills or your approach. Think how you can make a greater contribution to the business now.

Meet the Tiger challenge head-on...

Living with tuition fees

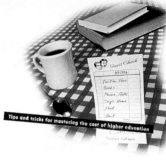

Tips and tricks for mastering the cost of higher education

Personal**vision**
Education

design
VICTORIA PRIMICIAS

art direction
JEAN-PIERRE VEILLEUX

illustration
**THOM SEVALRUD,
GREG MABLY**

photography
PER KRISTIANSEN

firm
LEAPFROG DESIGN GROUP INC.

client
**CANADIAN IMPERIAL BANK
OF COMMERCE**

Some key points to make your budget work

- Get as much firm information as possible on costs such as accommodation and moving expenses. If you have to guess at costs, estimate on the high side.
- Identify all your sources of income and when you expect to receive the funds (e.g. Government Student Loans may arrive after your tuition fees are due so you'll need money to tide you over.)
- Determine your fixed costs, such as rent and utilities, and when they are due (e.g. water, electricity, gas and your phone often have a one-time installation charge or connection fee.)

- **Estimate variable expenses, such as food, clothing, laundry, drug store items and entertainment (e.g. If you own a computer, stereo, TV or camera, don't forget insurance coverage).**
- **Don't overlook one-time expenses, such as trips home, birthday presents, books and course materials. Take advantage of student discounts and premiums whenever possible.**
- **Keep your budget current. Review it monthly and revise it as circumstances change.**

What if...

- you've got a lot of money at the beginning of the year, but nothing at the end? See "In the short-term you need access to your money" (Page 24 in "Building a Future").
- you've accounted for every cent but there's no room for emergencies or a great buy? See "A no-annual fee CIBC VISA Card can actually save you money" (Page 12 in "A VISA Card for Students").
- you definitely need a loan, but aren't sure what you need to qualify, and how you'll ever pay it back? (Page 23 in "How Much Can You Borrow?")

If you have money you don't need right away, consider buying a 90 day GIC or CIBC Money Market Fund. The rate of return may be better than in a savings account and it will give you peace of mind.

knowing your money is there for the second semester. Or consider putting the funds into a CIBC MaxiPlus™ account, which pays increasingly better returns based on the amount you can deposit.

If you know you'll get money back from your income tax return, invest it in an RRSP. As a student, you'll benefit two ways. The money goes to work earning tax deferred interest now, and you can carry the tax write-off forward to a future year, when you're in the work force and can benefit from the write-off.

How to squeeze every penny out of every dollar you have.

(Put this chart on your computer so it's easy to update and play out different "what if" scenarios. And modify this list of expenses to fit your particular situation.)

DATE LAST MODIFIED	SEP	OCT	NOV	DEC	JAN	FEB	MAR	APR
INCOME:								
SCHOLARSHIP								
BURSARIES								
FAMILY SUPPORT								
LOANS								
SAVINGS								
SUMMER JOB								
PART TIME JOB								
INVESTMENTS								
TAX REFUND								
OTHER								
TOTAL MONTHLY INCOME								
FIXED MONTHLY EXPENSES:								
TUITION & FEES								
MOVING EXPENSES								
RENT/MORTGAGE								
CONNECT PHONE								
CONNECT ELECTRICITY								
CONNECT GAS								
CONNECT WATER								
CONNECT CABLE								
INSURANCE								
FURNITURE								
LINENS/TOWELS								
PARKING FEES								
HEALTH STATUS								
LOANS								
SUPPLIES								
OTHER								
LESS TOTAL FIXED MONTHLY EXPENSES								
MONTHLY EXPENSES:								
RENT								
TRANSPORTATION								
CAR INSURANCE/REPAIR								
GASOLINE								
PARKING								
UTILITIES - WATER, HEAT, ELECTRICITY								
PHONE (LOCAL, LONG DISTANCE)								
GROCERIES								
LAUNDRY/DRY CLEANING								
ENTERTAINMENT								
DRUG STORE ITEMS								
LOAN AND CREDIT CARD PAYMENTS								
CLOTHING								
CHRISTMAS/BIRTHDAY GIFTS ETC.								
FEES/DUES								
OTHER								
LESS TOTAL MONTHLY EXPENSES								
MONTHLY BALANCE:								

Now that you can see where you stand, how often are your expenses higher than your income? Do you have to cut back somewhere? Find a cheaper place to rent? Your budget is a guide. By reviewing it regularly you can be ready when great opportunities come up, like your favourite music group just announced a last minute concert that'll be "to-die-for".

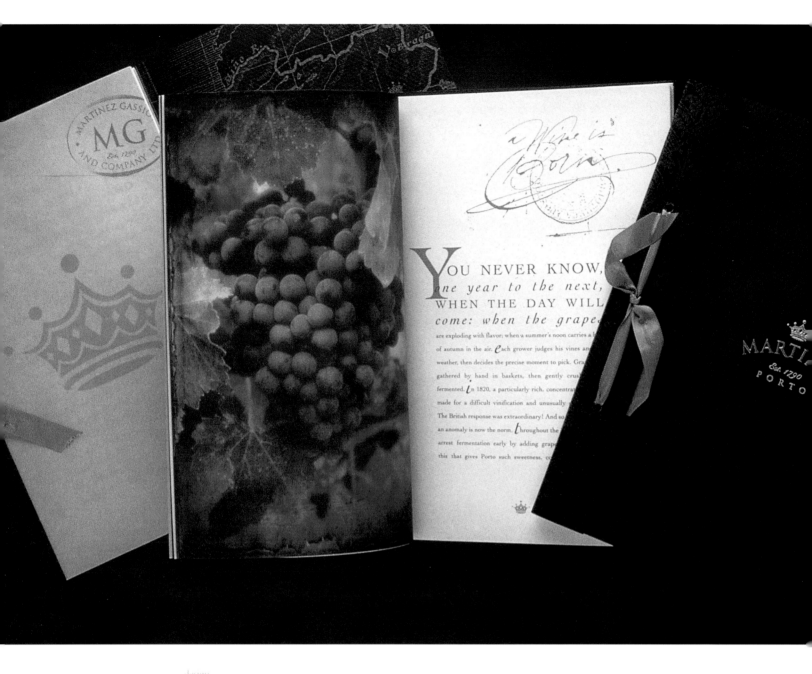

design
JACK ANDERSON,
LISA CERVENY, HEIDI FAVOUR,
MARY CHIN HUTCHISON

art direction
JACK ANDERSON, LISA CERVENY

illustration
JOHN FRETZ

photography
TOM COLLICOTT

calligraphy
NANCY STENTZ

firm
HORNALL ANDERSON

DESIGN WORKS

client
STIMSON LANE

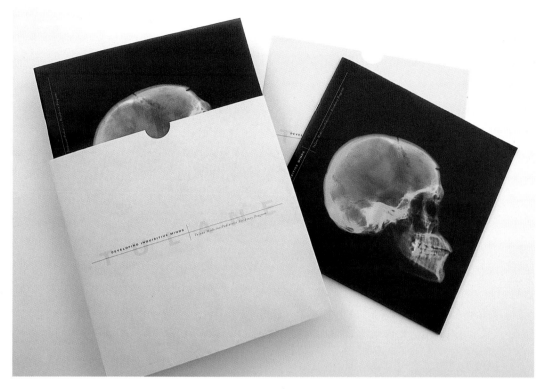

design
WINNIE HART, CHRISTY BRACKEN
art direction
WINNIE HART
photography
**JACKSON HILL—SOUTHERN
LIGHTS PHOTOGRAPHY**
firm
FARNET HART DESIGN STUDIO
client
**TULANE MEDICINE/PEDIATRICS
RESIDENCY PROGRAM**

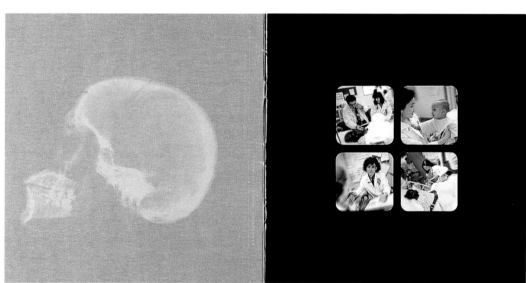

TULANE MEDICAL SCHOOL'S INTERNAL MEDICINE/PEDIATRIC RESIDENCY PROGRAM IS DESIGNED TO DEVELOP EXCELLENT CLINICIANS THROUGH COMPREHENSIVE TRAINING AND GRADUATED RESPONSIBILITY FOR PATIENT CARE. RESIDENCY TRAINING IS ENRICHED BY LIFE IN NEW ORLEANS ITSELF, A VIBRANT CITY WITH A HERITAGE OF MEDICAL EXCELLENCE.

Since 1988, our major goal has been to develop the inquisitive mind, the crucial element of clinical and laboratory investigation, and superb patient care. While training at Tulane University Medical Center, Tulane Hospital for Children, Charity Hospital and the Veterans Affairs Medical Center you'll gain an in-depth understanding of normal growth and development, the aging process, and diseases that affect infants, children, adolescents, adults and the elderly. Through clinical experience and intensive faculty instruction, you'll gain broad knowledge in Pediatrics and Internal Medicine, and develop the essential skills of history taking, physical examination and laboratory and clinical procedures.

When you, the resident, complete our program, you will have a strong foundation for a comprehensive primary care practice or subspecialty practice, as well as university or hospital-based practice, research or education. Whatever your ultimate goals, Tulane's Internal Medicine/Pediatrics Residency Program will give you the basis for a rewarding, fulfilling career.

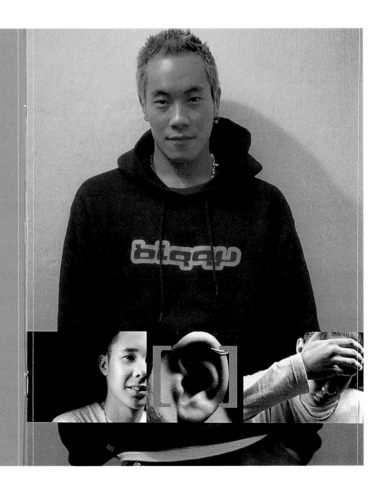

design
JON LEE
art direction
MANI RAO
photography
ANDY SHORT
firm
SATELLITE TELEVISION
ASIAN REGION LTD
client
CHANNEL [V]

Meet the [V] generation

That's right, that's what the youth of Asia call themselves. It's the [V] attitude that keeps them this side of cool. Who they are. Who they want to be. How they think. It's what Channel [V] eats, drinks and sleeps 24 hours a day and Channel [V] has become Asia's number one music channel because of it. It's so simple, it works. And it will work for you.

In India, Channel [V] attracts the highest proportion of upmarket young viewers	
Channel [V]	180
MTV	160
Sony	120
ATN	100
All Viewers	100

Index of 15-34 SEC A viewers

Source: IMRB Nov 97 (4 cities) Base: 15-24 A (482,000)

Channel [V] tops most popular channels in Hong Kong	
Channel [V]	19
STAR Sports	16
Phoenix	14
MTV	14
CNN	13

% viewing each week

Source: AMI PAX 97 Affluents 25-34 (1,463,000)

How can you miss? Channel [V] is the brain child of STAR TV and four of the biggest names in music entertainment, Sony, BMG, EMI and Warner.

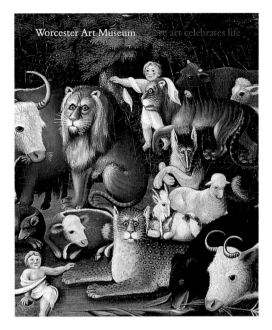

design
**JOYCE NESNADNY,
MARK SCHWARTZ,
BRIAN LAVY**

art direction
**MARK SCHWARTZ,
JOYCE NESNADNY**

firm
NESNADNY + SCHWARTZ

client
WORCESTER ART MUSEUM

re•member

"My great grand mother

was painted while her husband was an original Corporator of the Museum. My great-grandfather and uncle were presidents, and I now serve as Corporator."

The Sargent portrait of Stephen Dewey's great-grandmother, affectionately known as "Lizzie," is one of the Museum's prized pieces, hung in a place of honor in Stephen Salisbury Hall. Painted by the American master in 1890, the work was given by the sitter's granddaughter. For the Deweys and for numerous city residents, the Worcester Art Museum is a family tradition, often dating back to the Museum's founding days. Generation after generation has shaped a legacy of involvement and loyalty, which, in no small way, has contributed to the Museum's rise to prominence. When the Members' Council began in 1949, Robert Booth and Helen Stoddard were two of the Council's first members. They continue their close association with the Museum to this day. Museum member Dr. John Goldsberry, a retired physician whose wife, Dorista, is a Museum Corporator, traces his family's involvement to his grandfather, Charles Brown, an upholsterer who worked on the leather doors of the original building, and to his mother and sister who took art classes at the Museum and went on to become professional artists. For Polly Cowan, the Worcester Art Museum was a stimulating outing for her three sons when they were growing up. For twenty-five years, she has been an enthusiastic docent introducing countless visitors to the collections. She is especially proud of her fellow volunteers who are involved in the Museum's Docents in the Schools program. "Before school children visit the Museum, the docents take slides to the schools and show the children what they will be seeing. After the visit, the docents return to discuss the works the youngsters have viewed. It's a wonderful program." And Polly might add—someday many of the children will surely be bringing their children to the Museum and supporting its activities as members, docents, Corporators, board members and donors. The Worcester Art Museum legacy lives on.

Stephen Dewey, Worcester Art Museum Corporator

re•discover

"I'm a Moslem and it was exciting to learn about Islamic art during my Museum internship." Amane Abdeljabar, college student

"We hang out with the masters"

More than 700,000 people representing scores of different cultures live in central Massachusetts. The Worcester Art Museum would like more area residents to discover the cultural treasures in their backyard. To attract and engage a larger and more diverse audience and to develop more user-friendly programs and exhibitions, the Museum has designed a grassroots project called "The Art of Discovery." Launched in 1994, with the support of a $1.36 million grant from the Lila Wallace-Reader's Digest Fund, the initiative is under way in three nearby communities, chosen for their ethnic and economic diversity: Northborough, Marlborough and Burncoat High Visual Arts Magnet Program in Worcester. Fatinha Kerr, a member of The Art of Discovery Advisory Committee which includes business people, educators and civic and community leaders, cites how the Museum is striving to create audience-focused exhibitions and programs and to forge community partnerships. "When developing the Roman gallery, the Museum hung photographs of Roman artifacts in different locations in Marlborough and asked people to write down what they wanted to know and how they wanted it to be told." And that's just one aspect of The Art of Discovery's activities, which include exhibition flyers in Portuguese and Spanish, curricula custom designed for each of the three school systems, a Minority Internship Program, Family Days, mini-museums created by school children, and extensive outreach into the communities. It has not taken long for the project to have an impact on the Museum—in two years, attendance from Northborough alone jumped 430 percent at the fall exhibitions. Visitors to the redesigned Greek and Roman galleries now linger, reading exhibition labels offering an interdisciplinary approach to the collection. The Art of Discovery program and philosophy will continue to guide and inform the Museum, thanks to a $2.5 million endowment from the Stoddard Charitable Trust.

"The Museum is bringing art to all people. It's altering the perception that museums are for the elite or that you have to be knowledgeable about art to feel comfortable here."
Fatinha Kerr, Executive Director, Cultural Network Center of Marlborough

left to right: Sokun Souin, Jyothi Ramakrishnan, Marilyn Graglich, Amane Abdeljabar, Colin Spencer

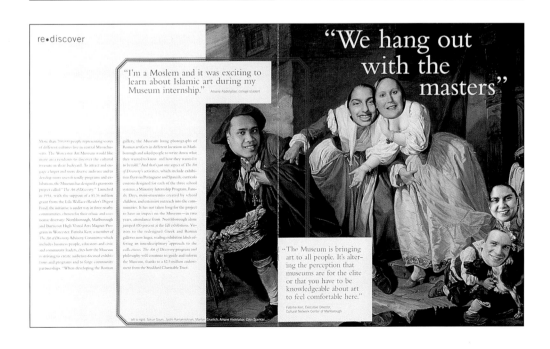

HAIFINANCE CORPORATION [HFC]

is an **INVESTMENT** company that targets **DYNAMIC** industries
and **INNOVATIVE** enterprises. Founded in 1983, HFC is distinguished by the international character of both its investments and management, a team with extensive international management, trade, and investment experience. HFC specializes in funded international expansion for U.S. emerging, growth companies. The Company provides entrepreneurs with the capital, expertise, and resources essential to success, adding value in such areas as business and financial planning, strategic sourcing, and market development. As an active and engaged investor, HFC enhances value, profitability, and growth, insuring long-term successes for both the Company and its Portfolio Companies.

INNOVATIVE

EXPANSIVE

INTENSE

GROWTH GROW

INVESTMENT COMMITMENT

HFC cultivates **EFFECTIVE** working relationships with Portfolio Companies based on mutual respect, shared goals, and realistic expectations. For its part, HFC makes a long term commitment, helping early and later stage investees through the growing pains they often encounter, ensuring the transfer and correct application of industry specific technical and marketing expertise, while supplying the business planning, financial, legal, and tax intelligence essential to expanding value. This know-how helps Portfolio Companies better meet world-class performance standards in terms of Quality, Speed, Cost, and Flexibility, important operational attributes that increasingly determine a company's success in competitive global markets. HFC also helps with identifying management and executive personnel; accessing additional capital through other venture partners; as well as arranging public offerings of stock.

INVESTMENT FOCUS

HFC seeks to invest in innovative companies that offer **ENDURING** shareholder value, generate excellent financial returns, and demonstrate a commitment to operating excellence, market leadership, and personnel empowerment. HFC places emphasis on the skills and qualifications of the management team by empowering leadership that is intensely committed to achieving the objectives described in a business plan, which should be a blueprint for building the company, rather than simply a sales tool for raising capital. While HFC's investments have spanned numerous international markets, industries, and sectors, all have been keenly innovative and responsive to emerging industry and market trends.

CUTTING-EDGE

EXPERIENCED

EFFECTIVE

DIVERSE DIVERSE

ENDURING

this page:
design
SOUNG WISER

art direction
MARIA SESE PAUL

creative direction
SUPON PHORNIRUNLIT

firm
SUPON DESIGN GROUP

client
FINANCE CORPORATION

opposite page:
design
**ERIC FREEDMAN,
GALE SPITZLEY**

art direction
JOHN BALL

illustration
MIGUEL PEREZ

writing
**JOHN KURAOKA,
ALAN WOLAN**

firm
MIRES DESIGN, INC.

client
GOCARD

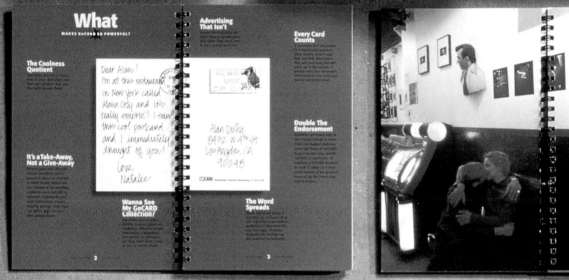

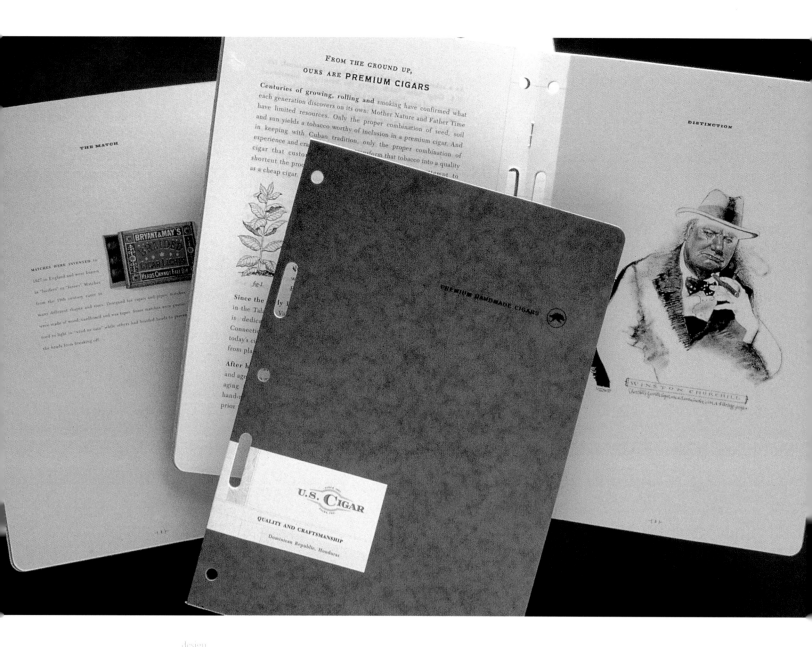

design
**LARRY ANDERSON, MARY HERMES,
MIKE CALKINS, DAVID BATES,
MICHAEL BRUGMAN**

art direction
**JACK ANDERSON,
LARRY ANDERSON**

illustration
**JACK UNRUH,
JOHN FRETZ, BILL HALINANN**

photography
DAVID EMMITE

firm
**HORNALL ANDERSON
DESIGN WORKS**

client
U.S. CIGAR

design
**FREEMAN LAU SIU HONG,
MAK TSING KUOH**

art direction
**KAN TAI-KEUNG,
FREEMAN LAU SIU HONG**

firm
**KAN & LAU DESIGN
CONSULTANTS**

client
**THE CHINESE UNIVERSITY OF
HONG KONG, DEPARTMENT
OF FINE ARTS**

R E S P E C T

A GUIDE FOR LEADERS

⊙ TARGET

TABLE OF CONTENTS

Increase your RESPECT-ability
through the use of ESTEEM BUILDING.

⊙ TARGET TIPS

○ When walking by a well built endcap, use your walkie talkie to let the entire team know.

○ When walking an area with your executives, build self-esteem by including the team leaders.

○ Break paradigms when walking your store. Include areas like the front end, food avenue, dock areas, and receiving.

○ Build a library of management books for your team leaders to demonstrate your interest in their development.

○ Ask your team members for their ideas. When you implement their ideas, give the team credit by saying, "It's great to have great thinkers like you on this team."

Your Ideas:

Never look down on a team member unless
you are helping them up.

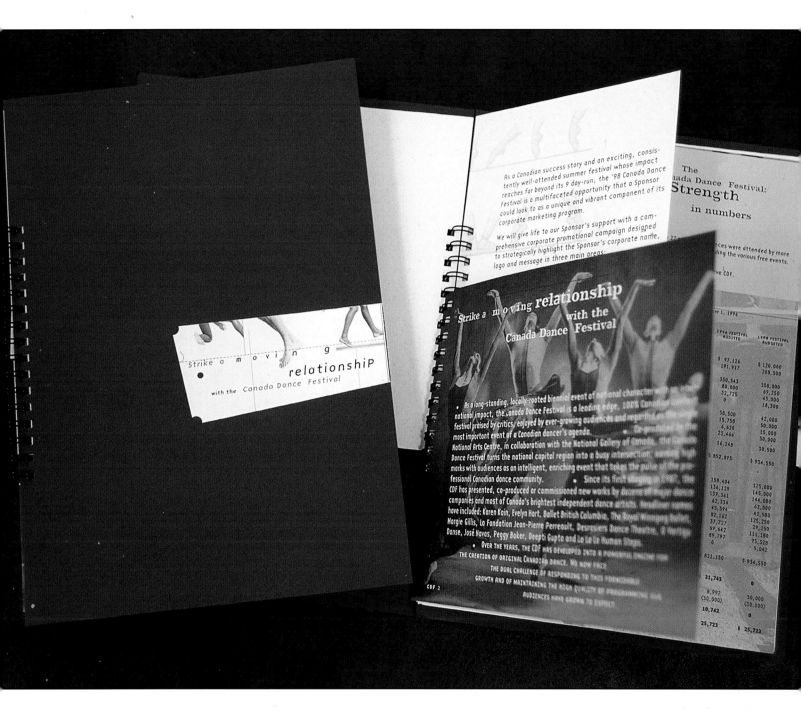

design
MARIO L'ÉCUYER
art direction
JEAN-LUC DENAT
photography
CANADA DANCE FESTIVAL
firm
IRIDIUM MARKETING & DESIGN
client
CANADA DANCE FESTIVAL

design
JOHN SAYLES

art direction
JOHN SAYLES

illustration
JOHN SAYLES

photography
BILL NELLANS

writing
WENDY LYONS

firm
SAYLES GRAPHIC DESIGN

client
JAMES RIVER PAPER

SOMETHING HAPPENS HERE
WASHINGTON, D.C.

design
**JAKE LEFEBURE,
ANDREW BERMAN**
art direction
**JAKE LEFEBURE,
ANDREW BERMAN**
creative direction
SUPON PHORNIRUNLIT
firm
SUPON DESIGN GROUP
client
**THE GEORGE WASHINGTON
UNIVERSITY**

Another

design
CORNWELL DESIGN PTY LTD

art direction
STEVEN CORNWELL

firm
CORNWELL DESIGN PTY LTD

client
CORNWELL DESIGN PTY LTD

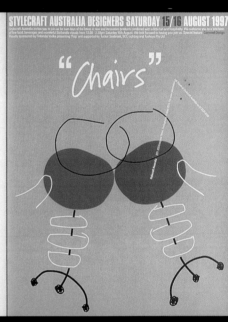

STYLECRAFT AUSTRALIA DESIGNERS SATURDAY **15/16 AUGUST 1997**

"Chairs"

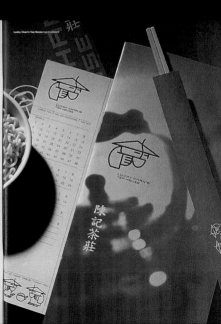

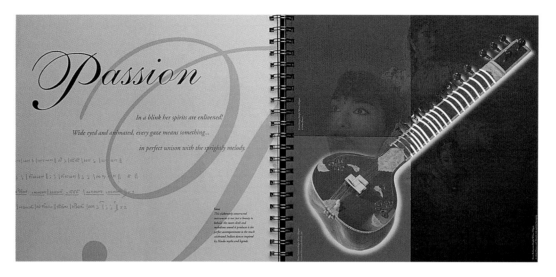

Passion

In a blink her spirits are enlivened!

Wide eyed and animated, every gaze means something...

in perfect unison with the sprightly melody.

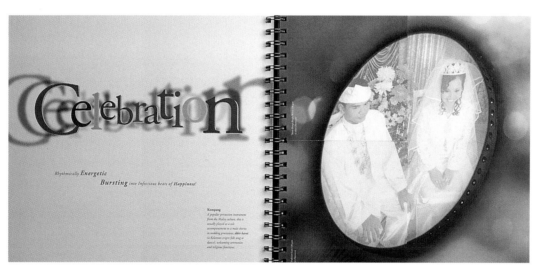

Celebration

Rhythmically Energetic
Bursting *into Infectious beats of* **Happiness!**

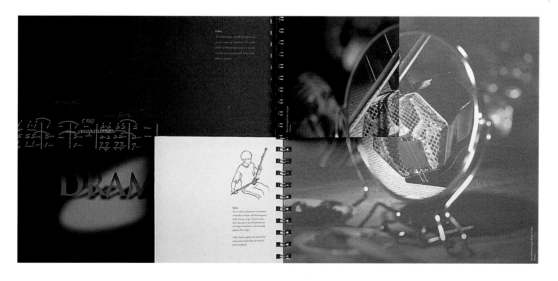

creative direction
TAN BENG SENG

firm
THE BLUE TANGERINE GROUP

design
KEVIN DEAN BUDELMANN
art direction
LIN VER MEULEN
photography
**HARRY SIEPLINGA
(INTERMEDIA),
STEVE RICHARDSON**
writing
JULIE RIDL
printing
ETHERIDGE
firm
SQUARE ONE DESIGN
client
SQUARE ONE DESIGN

ergonomics poster, Steelcase Incorporated

*We are most nearly ourselves
when we achieve
the seriousness of a child
at play.*

Heraclitus, philosopher

brochure and environmental display, Steelcase Incorporated

A ship in port is safe,
but that's not what ships are built for.

FOLLOW THE LEADERS

design
PENINA A. GOODMAN

photography
HORACE J. HICKS

firm
OXYGEN INC.

client
PORTFOLIO CENTER

I've never thought about being over the hill, only which one to climb.

PeaceCorps

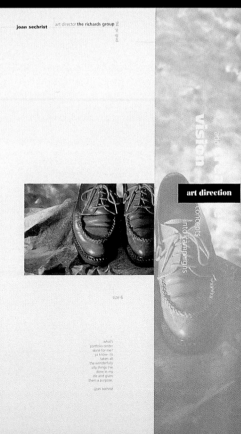

joan sechrist art director **the richards group**

vision

art direction

concepts
into campaigns

size 6

design
CORNWELL DESIGN PTY LTD
art direction
STEVEN CORNWELL
firm
CORNWELL DESIGN PTY LTD
client
EDWARDS DUNLOP PAPER

that Edwards Dunlop cut paper will never let him down in a crisis. Working under constant pressure there is little margin for error, and Edwards Dunlop supply his paper cut to size when he needs it the most. It may surprise you how big we are in papers for the digital print market.

SnapCollinsStreet

12:38pm

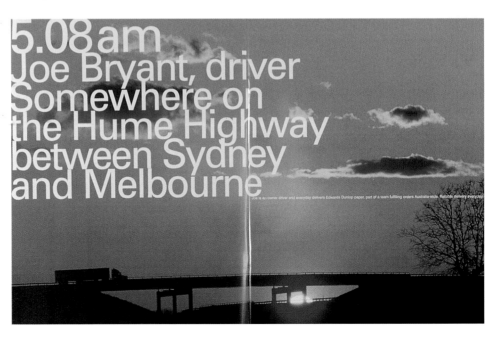

5.08am
Joe Bryant, driver
Somewhere on
the Hume Highway
between Sydney
and Melbourne

design
SONSOLES LLORENS
art direction
SONSOLES LLORENS
firm
SONSOLES LLORENS GRAPHICS
client
FUNDACIO LA CAIXA

Llorens Artigas

A Gallifa, Llorens posseeix el forn, el forn, el fornet. Per a produir l'esmalt del gres que produeix, el forn ha d'ésser posat a 1.300 graus de temperatura. El ceramista posa el gerro –o qualsevol altra peça– dins el forn, blanc, immaculat, el fa coure i sobre l'exterior dels objectes surten, quan la temperatura ha arribat al seu punt dolç, tota mena de colors: verds, grocs, ocres, roigs, blaus de totes les qualitats. És una pura meravella, una espècie d'indescriptible màgia. En aquesta operació, **tot és inseparable: la terra, la forma de l'objecte, la temperatura del forn, el vent, la situació meteorològica, la personalitat, tan plena d'experiència, de Llorens Artigas.** Aquesta operació l'ha feta davant de molta gent, d'alguns intel·lectuals, els quals, quan no tenen res a dir, utilitzen paraules estranyes. (OC 29, pàg. 514-515)

64

tot és inseparable:
la terra, la forma
de l'objecte,
la temperatura
del forn, el vent,
la situació
meteorològica,
la personalitat,
tan plena
d'experiència,
de Llorens Artigas

17. JOSEP LLORENS I ARTIGAS
(Barcelona, 1892 - 1980)

Ricart

Com a gravador al boix, Enric Cristòfol Ricart és un nom internacional. (OC 17, pàg. 285)

Treballava la fusta com si fos una cera. Ricart fou un tècnic prodigiós del gravat al boix, i, en aquest sentit, considerat per la crítica –de fora d'ací– com una personalitat de primera categoria. [...]
Enric C. Ricart porta la nostra vella tradició del gravat a extrems d'alta qualitat, d'insuperable domini. **En la seva persona es fongueren un virtuós de l'ofici i un artista de gran sensibilitat.** Cal recordar, a més a més, que fou així mateix un pintor molt discret, copiosament documentat, i un home cultivadíssim. (OC 17, pàg. 286)

62

En la seva
persona
es fongueren
un virtuós
de l'ofici
i un artista
de gran
sensibilitat

18. ENRIC CRISTÒFOL RICART
(Vilanova i la Geltrú, 1893 - 1960)
Beraar al forn
Xilografia acolorida. 30 x 40 cm
Biblioteca-Museu Víctor Balaguer. Vilanova i la Geltrú

THE MEXICAN MUSEUM

design
JENNIFER MORLA,
JEANETTE ARAMBURY
art direction
JENNIFER MORLA
firm
MORLA DESIGN
client
THE MEXICAN MUSEUM

EL MUSEO MEXICANO

REGARDING

RELATIONSHIPS

INTERWEST PARTNERS

design
KEVIN ROBERSON

art direction
BILL CAHAN

illustration
TIM BOWER

firm
CAHAN & ASSOCIATES

client
INTERWEST PARTNERS

ON TEAMWORK

IT TAKES
MORE
THAN
TWO TO
TANGO.

*One of the most important things we do
is help an entrepreneur build a high-performance
team with the right mix of experience and
the chemistry to work together effectively.*

JOHN ZEISLER

design
**SASCHA BOECKER,
MICHAEL HERSRUD,
CHAD AMON, KEVIN YLITALO**
art direction
PAUL WHARTON
illustration
**KEVIN YLITALO,
SASCHA BOECKER**
photography
**STEVE NIEDORF,
MARTY BERGLIN**
writing
LARS OSTROM
printing
**IMPRESSIONS, INC./
MCINTOSH EMBOSSING**
firm
LARSEN DESIGN + INTERACTIVE
client
IMATION ENTERPRISES, INC.

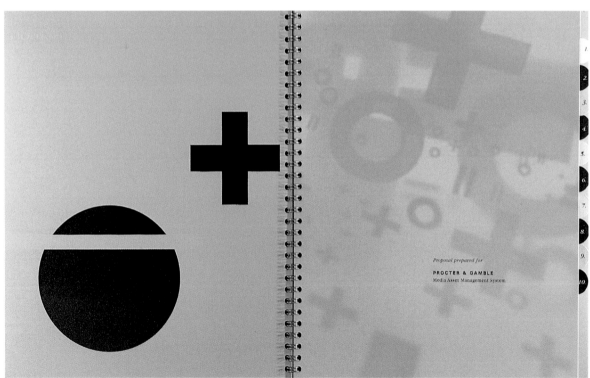

THE TRUSTEE NOTE BOOK

AN ORIENTATION FOR FAMILY FOUNDATION BOARD MEMBERS

NATIONAL CENTER
FOR FAMILY
PHILANTHROPY

design
PUM MEK-AROONREUNG
art direction
ANDREW BERMAN
creative direction
SUPON PHORNIRUNLIT
studio
SUPON DESIGN GROUP
client
**NATIONAL CENTER FOR
FAMILY PHILANTHROPY**

ADDITIONAL RESOURCES

Please refer to the Resource Map in Chapter IV for additional information about the following organizations and publications. This map provides a listing of resources by category: Boards & Governance, Family and Family Dynamics, Management and Operations, Grantmaking and Evaluation, and Philanthropy—General.

ORGANIZATIONS
Association of Small Foundations
Council on Foundations
National Center for Family Philanthropy
National Center for Nonprofit Boards
Regional Associations of Grantmakers

BOOKS
Duties and Responsibilities of Directors and Trustees of Illinois Private Foundations
Family Foundations and the Law: What You Need to Know
Foundation Desk Reference
Foundation Trusteeship: Service in the Public Interest
Governance (Family Foundation Library)
Handbook on Private Foundations
How to Manage Conflicts of Interest: A Guide for Nonprofit Boards
Law & Responsibilities: A Primer for Trustees, Directors and Officers of Michigan Private Foundations

MAGAZINES & NEWSLETTERS
Foundation News & Commentary
Family Matters (Legally Speaking)
National Center Journal
Trusts and Estates

For a list of specific articles related to the subjects discussed in this chapter, please contact the National Center at 202.293.3424.

THE BASIC RULES FOR GOVERNING A FAMILY FOUNDATION

BREAKING THE RULES IN PUBLICATION DESIGN

book

&

ook

ca

The most technologically efficient machine that man has ever invented is the book.
—Northrop Frye

n an era where instantaneous publications and digital communications are more popular than ever, one may have assumed that the shelf life of books was destined to come to a swift end.

Think again. Not only are books alive and well, they're even stronger than ever. The evidence? Record-breaking sales, more books, bigger stores, virtual shops, aggressive marketing, digital publishing deals... and better design.

Fact is, nothing can replace the intangible quality and stopping power of books. No other medium can accommodate such in-depth and sweeping content. No other periodical can stir the reader's senses in the same way. And today, with a new breed of open-minded editors and design-savvy publishers, no other publication can claim such a fresh direction in design.

"Book design has shifted and hopefully it will keep shifting," says Eva Roberts of the Eastern Carolina School of Art. "Today's culture gets used to things looking different, so clients and editors are more open to contemporary design."

Roberts, however, cautions that pushing the envelope should not be done just for the sake of looking different. According to the ECU art professor, the ultimate goal of book design is to enhance the content and to connect in a meaningful way with the reader. That means a valid and strong connection between design and copy.

Books offer qualities that appeal to all of the senses—resonant power that cannot be found in the more ephemeral nature of magazines or newspapers. Whether it's the touch of the paper, the smell of the ink, the elegance of the typography, or the magnetism of the graphics on the page—books provide a unique canvas on which designers can create.

Books still have structural "rules" which, when used smartly, can improve, rather than confine, effective design solutions. The time-honored grid format can dictate certain aspects of a book's design, but paper, graphics, text, and a range of typography still offer a world of creative possibilities. "When the publishers let you go," says Bill Douglas of The Bang in Toronto, "you can get away with more."

And nowhere do designers try to "get away with more" than on the book's cover. For obvious reasons, a book's cover can significantly influence a reader's perception of the content. According to Douglas, designing the appropriate look on the cover can make or break a title's success. "After all, people really do buy books just for the cover."

design
SHIN MATSUNAGA
artwork
SHIN MATSUNAGA
art direction
SHIN MATSUNAGA
firm
**SHIN MATSUNAGA
DESIGN INC.**
client
DAIICHISHIKO CO., LTD.

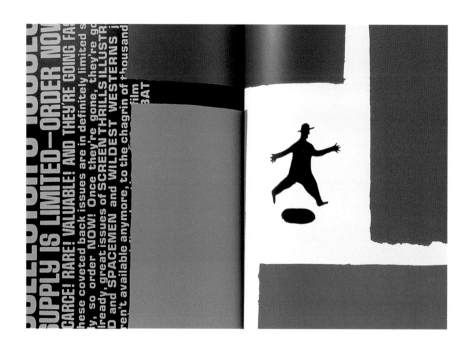

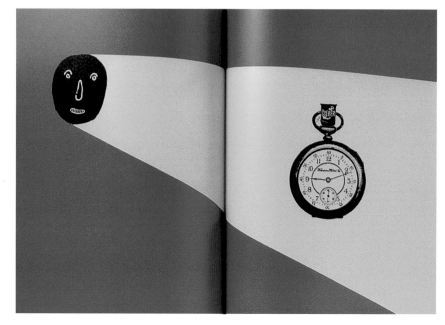

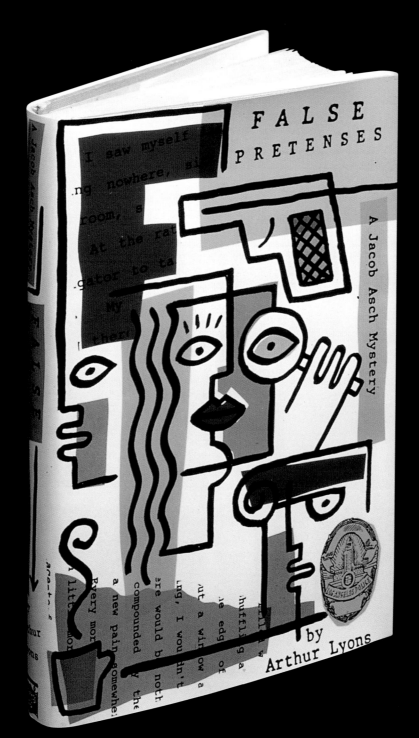

design
JOHN SAYLES

illustration
JOHN SAYLES

art direction
JOHN SAYLES

firm
SAYLES GRAPHIC DESIGN

client
WARNER BOOKS

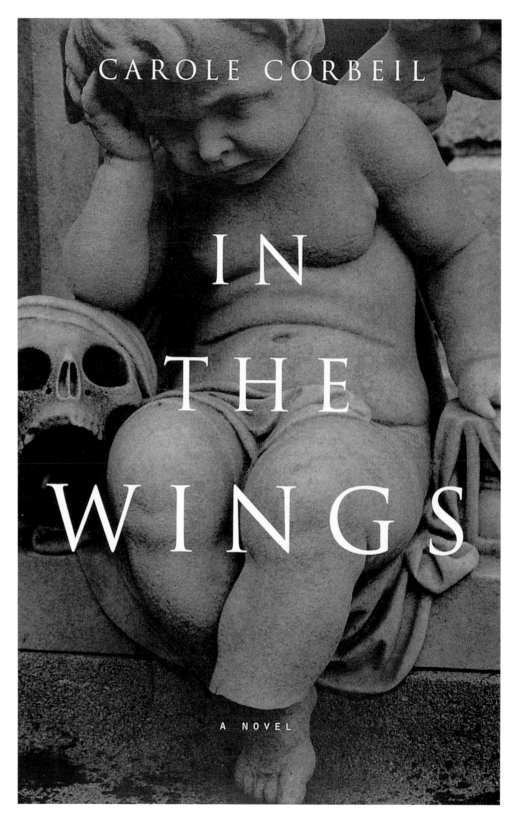

CAROLE CORBEIL

IN
THE
WINGS

A NOVEL

design
BILL DOUGLAS
art direction
BILL DOUGLAS
photography
PAMELA WILLIAMS
firm
THE BANG
client
STODDART PUBLISHING

Minnie Evans

ARTIST

design
**EVA ROBERTS,
STANTON BLAKESLEE**
art direction
EVA ROBERTS
firm
**EAST CAROLINA UNIVERSITY
SCHOOL OF ART**
client
**WELLINGTON B. GRAY
GALLERY**

twenty-two

Queen of Sheba - Mordatt
(no. Art, c. 1966
Graphite, oil and watercolor
on canvas board
18 x 24 inches, 45.7 x 61 cm.
Collection of Dorothea M. Silverman

twenty-three

Untitled (composite with female
face), S #213, 1967 (46, 18, 46, 62)
Graphite, oil, wax crayon and
collage on canvas board
21 x 26 1/2 inches, 53.3 x 67.3 cm.
Collection of Dorothea M. Silverman

EXHIBITION CHECKLIST

Works are listed chronologically, height precedes
width. Development numbers refer to cataloguing by
Nina Howell Starr, SP and Richard Gasparik, G#. T
indicates inclusion in traveling exhibition.

1
My Very First, 1935
Ink on paper
1 1/2 x 7 5/8 inches, 14 x 10 /sts
Collection of the Whitney Museum of American Art,
gift of Dorothea M. and Isadore Silverman

2
My Second, 1935
Ink on paper
3 3/4 x 7 5/8 inches, 14.6 x 19.4 cm.
Collection of the Whitney Museum of American Art,
gift of Dorothea M. and Isadore Silverman
(1 and 2 are framed together)

3
Untitled (abstract design with floral and leaf motif),
G #6, c. 1940
Graphite and wax crayon on paper
7 1/2 x 4 7/8 inches, 19.1 x 21.4 cm.
Estate of Minnie Evans, Courtesy of St. John's
Museum of Art

4
Untitled (bird and body with abstract symmetrical
design), T, G #12, c. 1940
Graphite and wax crayon on paper
7 1/8 x 4 7/8 inches, 18.7 x 12.4 cm.
Estate of Minnie Evans, Courtesy of St. John's
Museum of Art

5
Untitled (abstracted symmetrical design with six
faces), T, G #16, c. 1940
Graphite and wax crayon on paper
7 3/8 x 4 7/8 inches, 18.7 x 12.4 cm.
Estate of Minnie Evans, Courtesy of St. John's
Museum of Art

6
Untitled (abstract design with tree symmetrical
cloverleaf faces), T, G #18, c. 1940
Graphite and wax crayon on paper
7 3/8 x 4 15/16 inches, 18.7 x 12.8 cm.
Estate of Minnie Evans, Courtesy of St. John's
Museum of Art

7
Untitled (abstract design of circles and dots),
G #10, c. 1940
Graphite and wax crayon on board
7 7/16 x 4 15/16 inches, 18.6 x 12.5 cm.
Estate of Minnie Evans, Courtesy of St. John's
Museum of Art

8
Untitled (abstract design with faces and nuts),
S #16 L, c. 1940
Graphite and wax crayon on paper
7 x 5 inches, 17.8 x 12.7 cm.
Private collection

9
Untitled (abstract design of web with creatures),
S #16 L, c. 1940
Graphite on paper
7 x 5 inches, 17.8 x 12.7 cm.
Private collection

10
Untitled (abstract design of bull's head),
S #2 El, c. 1940
Graphite and wax crayon on paper
7 1/2 x 5 inches, 19.1 x 12.7 cm.
Collection of Nina Howell Starr

11
Untitled (abstract design of bull's head),
S #439, c. 1940
Graphite, ink and wax crayon on paper
7 1/2 x 5 inches, 19.4 x 12.7 cm.
Collection of Nina Howell Starr

twelve

Untitled (abstract symmetrical design with pink appendages)
G #234, c. 1930
Graphite, ink and wax crayon on paper
11 7/8 x 8 15/16 inches, 29.5 x 22.7 cm.
Estate of Minnie Evans, Courtesy of St. John's Museum of Art

thirteen

Untitled (abstract butterfly design)
G #73, c. 1930
Graphite, ink and wax crayon on paper
11 15/16 x 8 15/16 inches, 30.3 x 22.7 cm.
Estate of Minnie Evans, Courtesy of St. John's Museum of Art

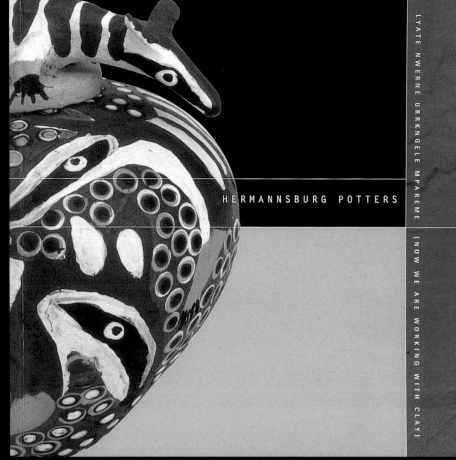

HERMANNSBURG POTTERS

LYATE NWERNE URRKNGELE MPAREME

(NOW WE ARE WORKING WITH CLAY)

design
GEORGE MARGARITIS

art direction
MARCUS LEE

photography
ROBERT COLVIN

firm
MARCUS LEE DESIGN

client
**MUSEUM & ART GALLERY OF
THE NORTHERN TERRITORY**

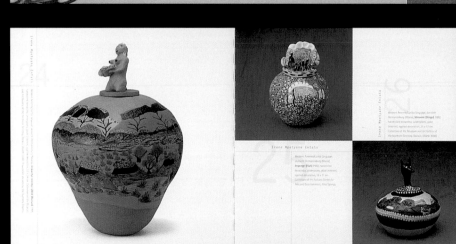

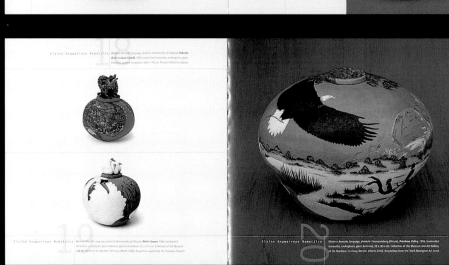

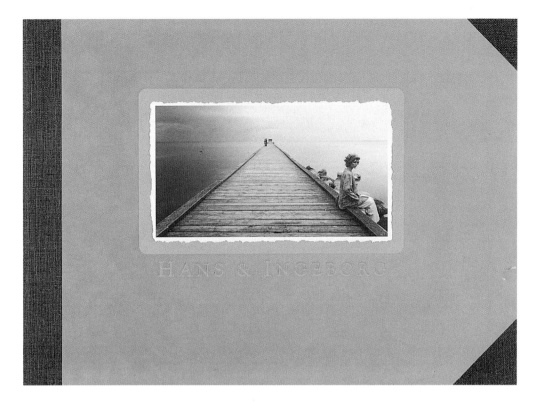

design
FRANK MAZZUCA
art direction
FRANK MAZZUCA
photography
V. TONY HAUSER
firm
**MAZZUCA DESIGN: DESIGN,
PHOTOGRAPHY & IDEAS**
client
V. TONY HAUSER

Hans chose Ingeborg to be his mate.

On their vacations Hans went sailing.

Ingeborg remained unfulfilled.

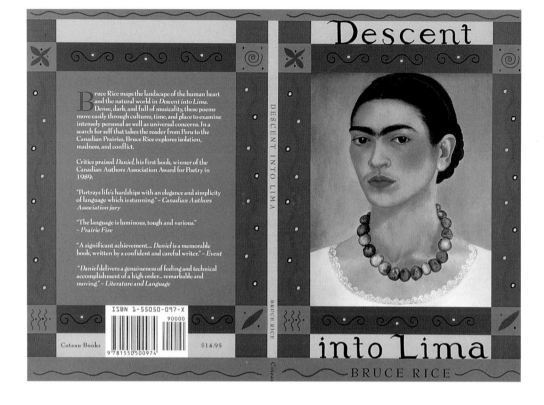

design
CATHARINE BRADBURY
art direction
CATHARINE BRADBURY
illustration
FRIDA KAHLO
firm
BRADBURY DESIGN
client
COTEAU BOOKS

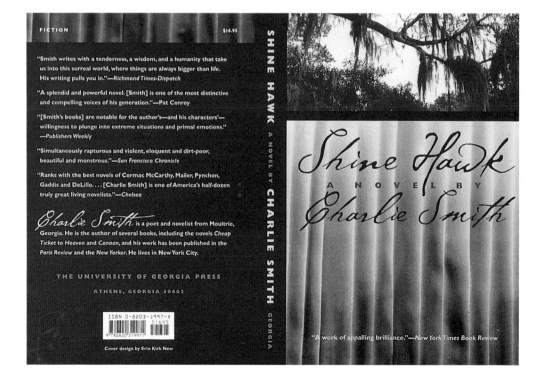

design
ERIN KIRK NEW
photography
ERIN KIRK NEW
firm
UNIVERSITY OF
GEORGIA PRESS
client
UNIVERSITY OF
GEORGIA PRESS

El Dorado

SHUFFLE

MORGAN NYBERG

design
BILL DOUGLAS
art direction
BILL DOUGLAS
photography
CHRIS CHEETHAM
firm
THE BANG
client
CORMORANT PUBLISHING

74

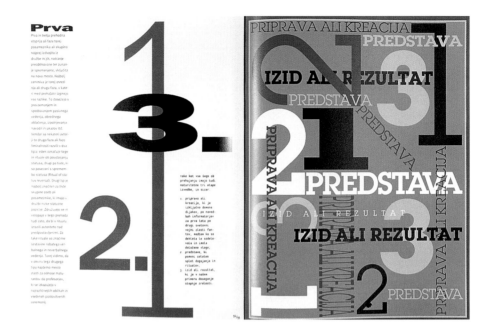

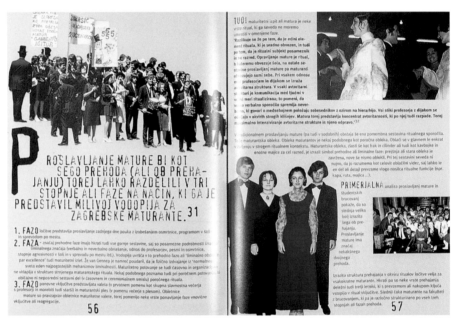

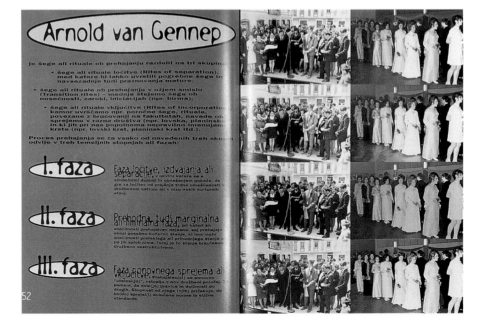

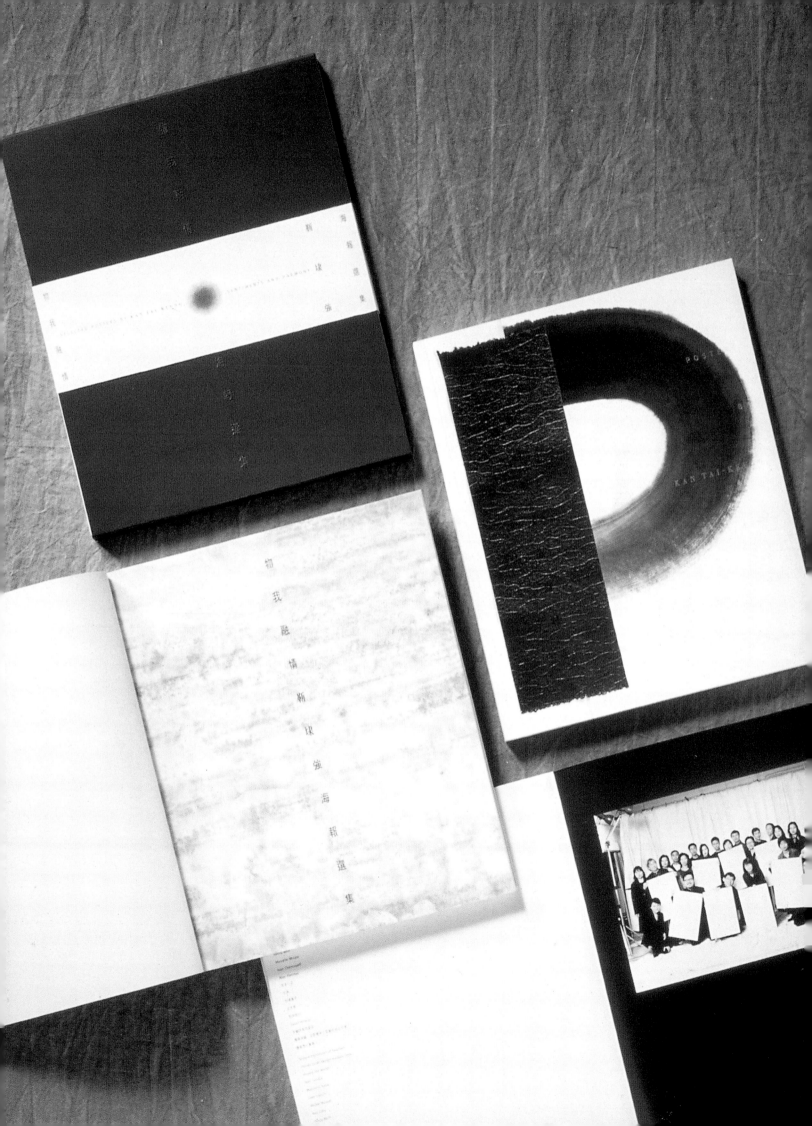

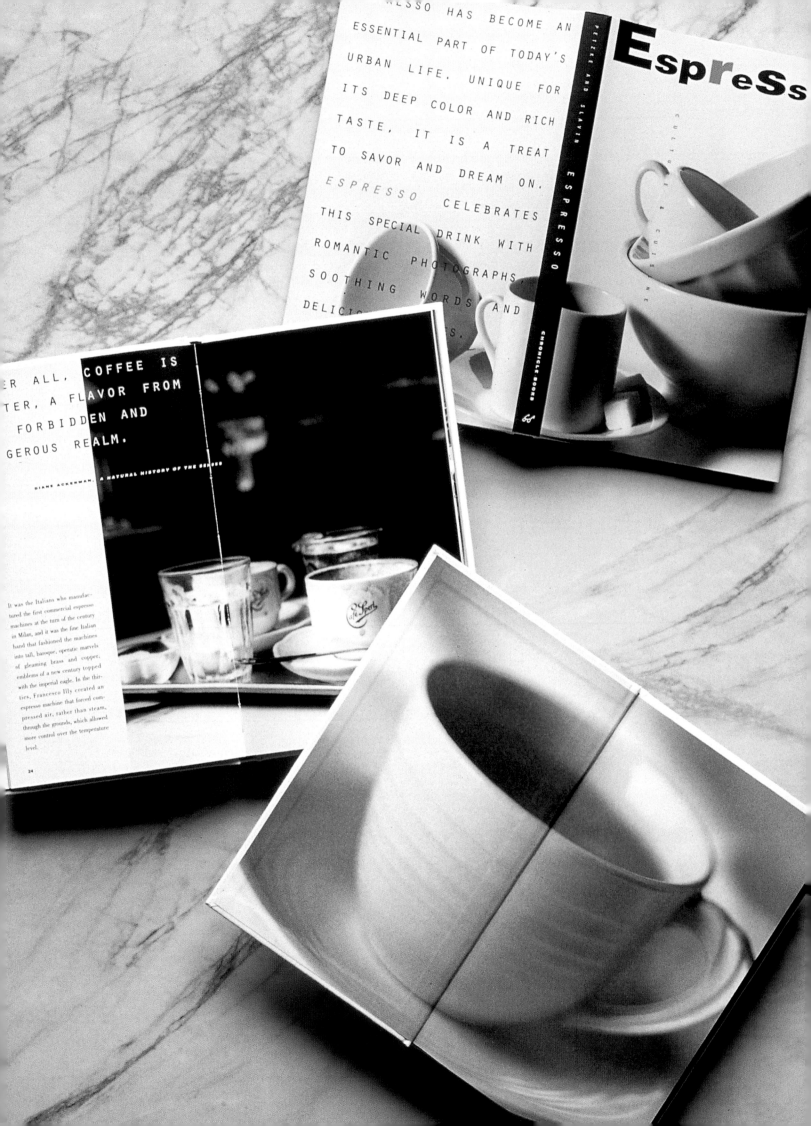

this page:
design
SEAN CARTER
art direction
VIDA JURCIC
photography
ROBERT KENNEY
writing
NIGEL YONGE
firm
HANGAR 18 CREATIVE GROUP INC.
client
RICHMOND CENTRE

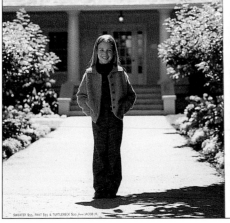

opposite page:
design
JENNIFER MORLA,
SHARRIE BROOKS
art direction
JENNIFER MORLA, SARA SLAVIN
photography
KARL PETZKE
firm
MORLA DESIGN
client
CHRONICLE BOOKS

design
JAY THEIGE

art direction
STEVEN SIKORA

photography
DARRELL EAGER,
MICHAEL CROUSER

writing
JAY KASKEL,
STEVEN SIKORA

firm
DESIGN GUYS

client
TARGET STORES

herbasis™

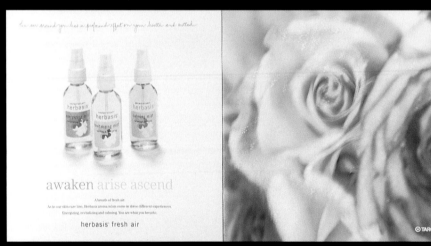

the air around you has a profound effect on your health and outlook

awaken arise ascend

A breath of fresh air.

As in our skin care line, Herbasis aroma mists come in three different experiences.
Energizing, revitalizing and calming. You are what you breathe.

herbasis® fresh air

⊙ TARGET

FORMULATED
in harmony
with nature

Every element in the Herbasis aromatherapy line
is formulated to gently repair your body and spirit.
Not to mention your mind and spirit.
Our products are cruelty free,
and packaging comes from the harvesting
of herbasis®
Well beyond beauty. Where you want to be.

⊙ TARGET

Herbal extracts and oils used in herbasis

Bergamot oil *soothing yet relaxing, promotes healing* Black pepper *increases circulation in skin* Calendula *healing and antiseptic properties* Cedarwood oil *acts as an astringent and deep cleanser* Chamomile *healing, relaxing, cleansing and soothing properties* Clary sage *soothes, calms and is a relaxant to the skin* Clove *powerful cleansing properties and revitalizing on the skin* Comfrey *renowned for its healing qualities* Eucalyptus oil *refreshing, stimulating and antiseptic properties to the skin* Flax seed *emollient and skin cleansing* Frankincense *deeply relaxing, calming and toning to the skin* Geranium oil *slightly stimulating and in some cases relaxing, balancing to the skin* Ginseng *revitalizes and invigorates* Henna leaves *one of the most effective colorants* Honey *skin nourishing and softening properties* Hops strobilus *relaxant to the skin* Horsetail *an effective healing agent* Jasmine *intensely warm and calming, soothing and uplifting* Juniper berry oil *deep cleansing and an astringent* Lavender oil *deep cleansing and balancing qualities* Lemongrass *gently astringent and cleansing action on the skin* Mint leaves *especially useful for its cleansing and refreshing properties* Neroli *calming, relaxing and used as a skin revitalizer* Nettle leaves *one of the highest vitamin C contents of any plant* Orange oil *energizing and refreshing to the skin* Palmarosa *hydrating and stimulating, antiseptic to the skin* Patchouli *calming, deep cleansing and revitalizing to the skin* Peppermint oil *stimulating and mild deep cleansing action* Rose oil *calming and relaxing to the skin* Rosemary *cleansing action with stimulating properties to the scalp* Sage *scalp and skin stimulant properties* Sandalwood *effective relaxant and promotes healing* Tea tree oil *stimulating tonic with deodorant action* Watercress *cleansing and gently stimulating to the skin* Wheat amino acids *essential nutrients to feed scalp and hair* Witch hazel *gentle cleansing, healing and antiseptic action* Ylang-ylang *calming, relaxing and effective at balancing the skin*

JUST BECAUSE A BIKE IS MADE BY HAND,
DOESN'T MEAN YOU'D WANT TO RIDE IT.

design
BOB DINETZ

art direction
BILL CAHAN

photography
ROBERT SCHLATTER

illustration
BOB DINETZ,
TREK BICYCLE CORPORATION

firm
CAHAN & ASSOCIATES

client
TREK BICYCLE CORPORATION

SOMETIMES,

THE MOST
BEAUTIFUL PART
IS THE ONE
YOU CAN'T SEE

KLEIN

MANTRA

Most full suspension bikes have been designed as if the world
was all downhill. But a good portion of land out there is flat
and the rest is all uphill. The Mantra differs from most full
suspension bikes in that it actually climbs better than a lot of
hardtails, flies across the flatlands and still provides big bump
performance when going downhill. Like all Kleins, the Mantra
is super lightweight (up to five pounds lighter than comparably
priced full suspension bikes). And the oversized Klein Torque
Control Beam™ is connected to an ultra-stiff Unified Rear
Triangle, which allows the Mantra frame to be more laterally
rigid than many hardtails. The point of connection is an over-
sized pivot—the Klein Spot-On Pivot location (explained in
detail by Gary Klein on page 15), making for the most efficient
full suspension bike on the market.

4 –

Standing Four-Armed Harihara

Pre-Angkor period
Style of Prasat Andet
Ca. last quarter of the 7th century
Height: 23 inches (58.4 cm.)

It is most unusual and decidedly informative to find a Pre-Angkorian sculpture with its supporting arch intact. It is particularly rewarding when, as here, it is combined with a sculpture of superior aesthetic qualities.

The illustrated image is a representation of Harihara, the cult-icon combining the forms of Vishnu and Shiva. As usual, Hari (Vishnu), identifiable by his cylindrical miter and attributes, the conch held in the upper left hand, and the lowered left hand placed on the upper part of a battle-mace, occupies the left side, the less important side. Hara (Shiva), immediately recognizable by his special hair arrangement, plaits (*jatas*) piled high on the head that then descend in loops, holds his trident, depicted in profile, in his raised hand. Whatever was held in the lowered right hand – perhaps a lotus bud – has not survived. The back of the head and the raised arms with the attributes are attached to the arch, while the two projecting lower hands are supported by outward-curving struts. By the first quarter of the ninth century, the Cambodian sculptors were able to abandon this supporting arch system and by the middle of the century, the struts.

Harihara stands in the frontal *samabhanga* posture, the knees locked and both feet planted firmly on the pedestal. His *sampot* is arranged in

proper Prasat Andet style with a part of the cloth gathered from the left side tucked into the front of the upper hem. The pleated end then falls in a splayed flaring panel. The section of the garment pulled between the legs is brought up in back beneath the belt and tucked in on top. The falling small panel echoes the shape of the one in front. The garment appears to be of a light weight and tightly adheres to the body.

The body is very well-modeled with equal attention paid to all its parts, including the feet. The back of the deity in particular, with its carefully controlled arrangement of gentle volumes, illustrates the sculptor's consummate skill in manipulating form and surface.

The features of the youthful face are precise and well-executed; the eyes are outlined, the nose is finely shaped, and the curve of the lips establishes the authoritative expression. The plaits of hair on the Shiva side are uniform and handsomely arranged; the decoration on Vishnu's miter is an attractive pattern of diamonds enclosing small circles (best seen at back). The short earlobes of the well-formed ear are pierced to receive adornments.

It is very interesting to compare this Prasat Andet-style Harihara with the one in the collection of the Metropolitan Museum,[3] and two in the museum in Hanoi.[4]

10

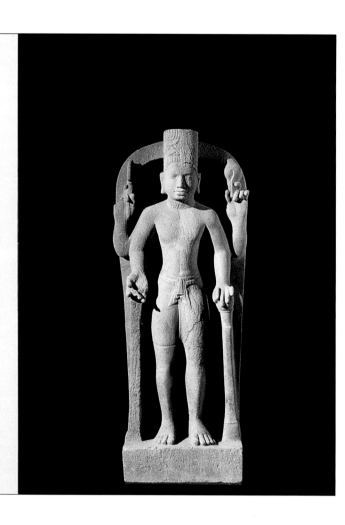

design
NELIDA NASSAR
art direction
NELIDA NASSAR
photography
RICHARD GOODBODY
firm
NASSAR DESIGN
client
**THE CHINESE
PORCELAIN COMPANY**

Butterfield & Robinson

The World's Great Biking Journeys

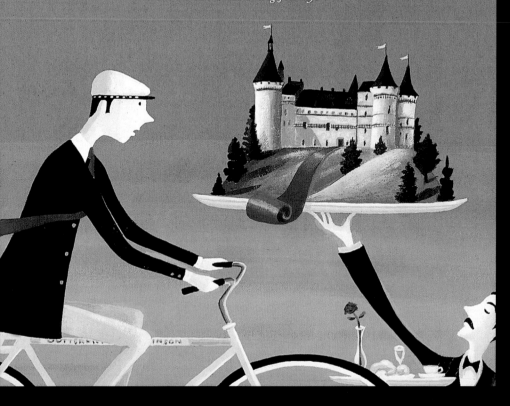

design
FRANK VIVA

art direction
FRANK VIVA

writing
DOUG DOLAN

photography
RON BAXTER SMITH,
MACDUFF EVERTON,
HILL PEPPARD,
STEVEN ROTHFELD

printing
ARTHURS JONES
LITHOGRAPHING LTD.

firm
VIVA DOLAN
COMMUNICATIONS & DESIGN

client
BUTTERFIELD & ROBINSON

life

PERIENCE

"We couldn't have arranged this on our own."

A hallmark of B&R's style is our talent for presenting memorable treats that would be difficult, if not impossible, to arrange on your own. In more than three decades of biking to the ends of the earth, we've established relationships with interesting people whose unique local perspectives are integral to our trips. We count on these friends to reveal a region's secrets through private art tours, exclusive access to historic sites and every imaginable kind of tasting. From wine to chocolate to fresh olive and sea-salt oils. They lead us to undiscovered treasures, share their favourite unveil list in a well-earned experience, and even invite us into their homes. From gardener showing off prized blooms to anthropologists deciphering prehistoric art, B&R's local experts create authentic experiences you won't find in any guidebook.

◄ Leah Rabinowitz of New York City set a goal of visiting every major château in the Loire Valley — and with our help, she did it.

1

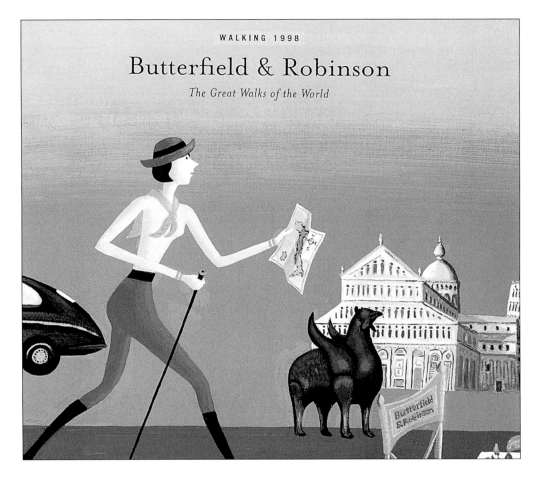

design
FRANK VIVA
art direction
FRANK VIVA
writing
DOUG DOLAN
photography
**RON BAXTER SMITH,
MACDUFF EVERTON,
HILL PEPPARD,
STEVEN ROTHFELD**
printing
**ARTHURS JONES
LITHOGRAPHING LTD.**
firm
**VIVA DOLAN
COMMUNICATIONS & DESIGN**
client
BUTTERFIELD & ROBINSON

design
FRANK VIVA

art direction
FRANK VIVA

writing
DOUG DOLAN

writing
**ROYAL GEOGRAPHIC SOCIETY,
CHARLIE SCOTT,
DAVID SWALES**

maps
TERRY SHOFFNER

firm
**VIVA DOLAN
COMMUNICATIONS & DESIGN**

client
BUTTERFIELD & ROBINSON

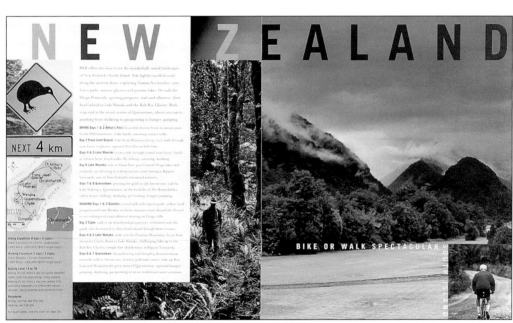

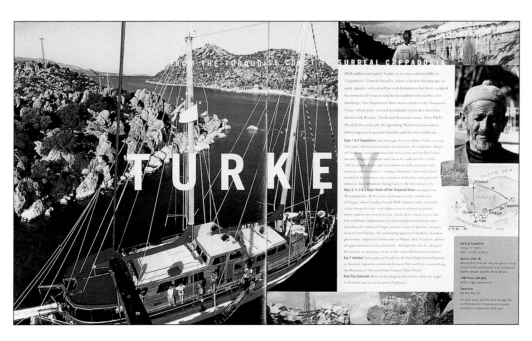

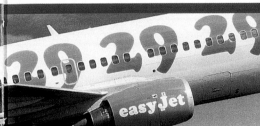

Business telecoms *takes off*

"With its fibre-optic network NTL can give us fast extra phone capacity at Luton airport whenever we need it – often overnight. We use over 200 ISDN lines when coping with national promotional flight bookings, and we're working with NTL on links that let our Call Centre people work from home."

easyJet *Clive Just, IT Manager,*
easyJet Airline Company Limited

Achieving national reach

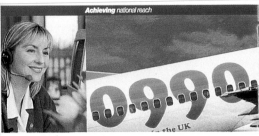

Creativity: A really creative designer excels by making your message unique, thereby increasing the chances of it being noticed and remembered. The creative solution is usually hidden within the story and a talented designer will 'find' it and deliver it in the most appropriate way.

Creditors: A statement on a company's policy and practice regarding payment of suppliers is a legal requirement, usually covered within the Directors' report.

Crest: This computerised system connects banks, stockbrokers and registrars, allowing share transactions to be conducted without the interchange of paper documentation. The smaller private shareholder may prefer to continue to hold traditional share certificates, but larger private investors will probably decide to use the Crest system via a nominee. Although this means that they do not appear individually on a company's shareholder register, the nominee will arrange for them to be sent copies of the company's AR or Summary Financial

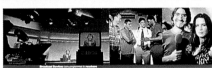

The easyJet telephone number livery lent itself beautifully to demonstrating NTL's advanced telecommunications services for business. The benefits of NTL's digital transmission services also added up for Channel 3+4+5.

22

23

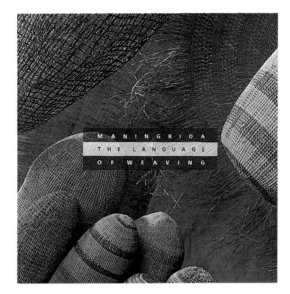

design
GEORGE MARGARITIS
art direction
MARCUS LEE
photography
RICK BAWDEN
firm
MARCUS LEE DESIGN
client
**MUSEUM & ART GALLERY OF
THE NORTHERN TERRITORY**

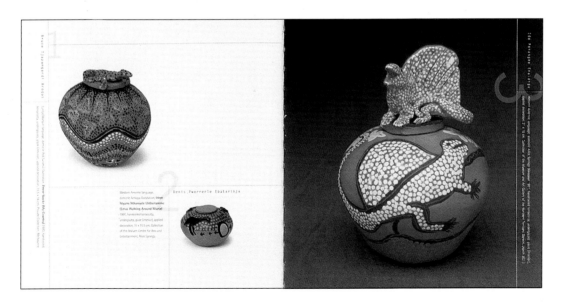

86

design
EMILY RAIVELY, AMBER TRAVEN
art direction
MARYANN MITKOWSKI
(PARHAM SANTANA, INC),
MIKE DAWSON
(GOLDEN BOOKS)
creative direction
MARUCHI SANTANA
(PARHAM SANTANA, INC),
ELLEN JACOB
(GOLDEN BOOKS)
editorial direction
LINDA HAYWARD
(GOLDEN BOOKS)
firm
PARHAM SANTANA, INC.
client
GOLDEN BOOKS FAMILY
ENTERTAINMENT

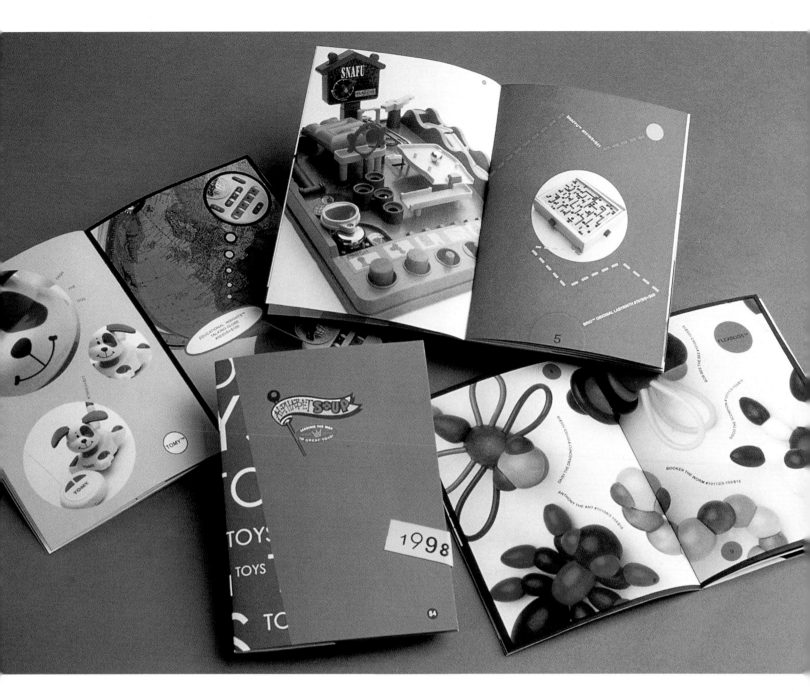

design
JOHN SAYLES
art direction
JOHN SAYLES
photography
BILL NELLANS
firm
SAYLES GRAPHIC DESIGN
client
ALPHABET SOUP

design
CATHARINE BRADBURY
art direction
CATHARINE BRADBURY
photography
**SASKATCHEWAN
ARCHIVES BOARD**
illustration
CATHARINE BRADBURY
firm
BRADBURY DESIGN
client
SASKATCHEWAN MOTION

SASKATCHEWAN

SMPIA

Motion Picture

A S S O C I A T I O N

98-99

DIRECTORY

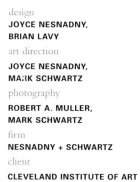

eland **institute of art** ceramics drawi
meling fiber glass graphic design illustrati
strial design interior design medical illustration met
ting photography printmaking sculptu

design
**JOYCE NESNADNY,
BRIAN LAVY**

art direction
**JOYCE NESNADNY,
MARK SCHWARTZ**

photography
**ROBERT A. MULLER,
MARK SCHWARTZ**

firm
NESNADNY + SCHWARTZ

client
CLEVELAND INSTITUTE OF ART

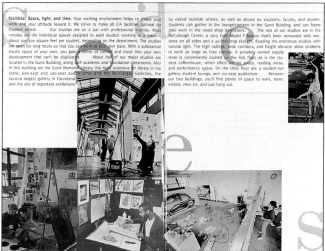

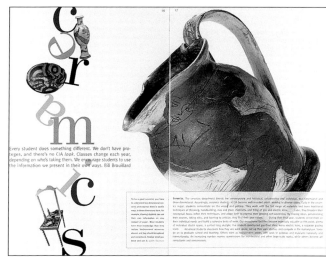

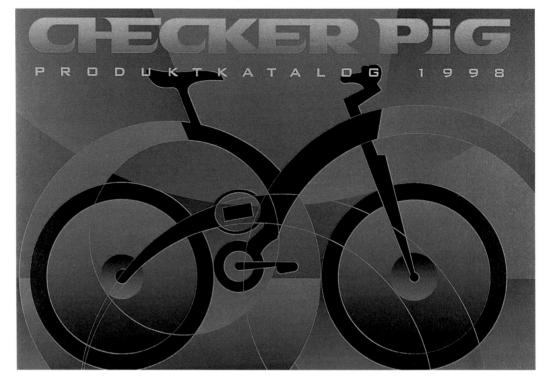

design
ANDREAS KARL
art direction
ANDREAS KARL
photography
KATHRIN HOHL
firm
KARL DESIGN
client
PIG BIKE GMBH

design
DAVID BATES, LISA CERVENY

art direction
JACK ANDERSON, DAVID BATES

photography
CONDIT STUDIO

illustration
JACK UNRUH

firm
**HORNALL ANDERSON
DESIGN WORKS**

client
LEATHERMAN TOOLS

design
FRANCIS LEE

art direction
ERIC CHAN

firm
ERIC CHAN DESIGN CO. LTD.

client
ITALIAN TRADE COMMISSION

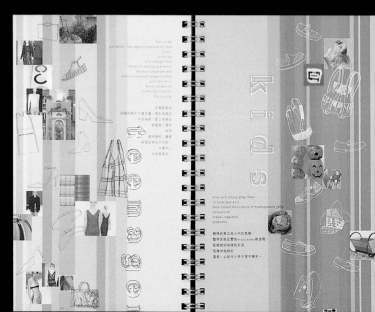

design
ERIC CHAN
art direction
ERIC CHAN
illustration
BONNIE CHAN
firm
ERIC CHAN DESIGN CO. LTD.
client
ERIC CHAN DESIGN CO. LTD.

design
TOR PETTERSEN
art direction
TOR PETTERSEN
firm
**TOR PETTERSEN &
PARTNERS LTD**
client
**TOR PETTERSEN &
PARTNERS LTD**

Idea based design
created to make
corporate communication
interesting, informative,
entertaining
or even surprising.
Selected work by
Tor Pettersen & Partners

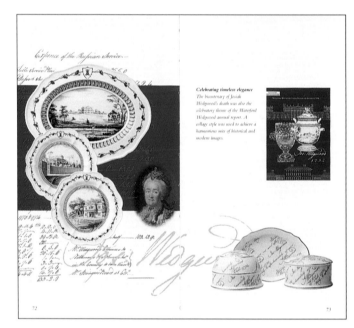

Celebrating timeless elegance
The bicentenary of Josiah
Wedgwood's death was also the
celebratory theme of the Waterford
Wedgwood annual report. A
collage style was used to achieve a
harmonious mix of historical and
modern images.

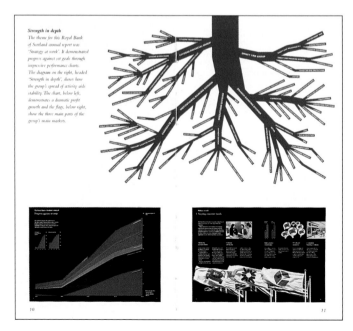

Strength in depth
The theme for this Royal Bank
of Scotland annual report was
'Strategy at work'. It demonstrated
progress against set goals through
impressive performance charts.
The diagram on the right, headed
'Strength in depth', shows how
the group's spread of activity aids
stability. The chart, below left,
demonstrates a dramatic profit
growth and the flags, below right,
show the three main parts of the
group's main markets.

**Erfolgreich
durch
Corporate
Design**

initiative corporate design

design
**CLEMENS HEIDER,
ANDREA KLAUSNER**

illustration
MICHAEL AMMAN

writing
**INITIATIVE
CORPORATE DESIGN**

firm
HEIDER & KLAUSNER

client
**INITIATIVE
CORPORATE DESIGN**

Kein CD ohne CI
— warum?

Damit CD funktioniert, müssen Handeln und Kommunikation aufeinander abgestimmt sein. CI (die festgeschriebenen Prinzipien) ermöglicht diese Abstimmung.

CI vermitteln durch Verhalten

CI definiert eine Vision und Rahmenbedingungen, wie diese Vision verwirklicht werden kann. Diese Rahmenbedingungen sind Leitsätze, die Verhalten, Kommunikation und Erscheinungsbild betreffen. Maßnahmen für die einzelnen Teilbereiche werden damit erstellt, beurteilt und ausgeführt.

CD-Arbeit ermöglicht, CI bewußt zu machen. Im Zuge der CD-Arbeit werden oft Fragen gestellt, deren Beantwortungen CI-Rang haben. Um diese Fragen zu beantworten, muß sich der Unternehmer über verschiedene grundsätzliche Standpunkte klar werden, vor allem deshalb, um die Gestaltung eines auf ihn zugeschnittenen, stimmigen Erscheinungsbildes zu ermöglichen (es geht nicht um ein schönes Logo eines sich selbstverwirklichenden Grafikers, sondern um die adäquate visuelle

CI vermitteln durch nonverbale Äußerungen

Kommunikation eines ganzen Unternehmens inklusive seines Verhaltens und seiner verbalen Kommunikation). Zufällige Entwicklungen (also unbewußtes CI) werden so im Zuge der CD-Arbeit bewußt gemacht und dadurch steuerbar.

Die Motivation, die üblicherweise im Zuge einer CD-Entwicklung entsteht, läßt sich nun gut dazu nützen, dieses CI-Light zu formulieren. Festgeschriebene Prinzipien ermöglichen es, das gewünschte Soll-Image in der Öffentlichkeit entstehen zu lassen – das kann Änderungen der Unternehmensstruktur oder der Art, wie mit Kunden oder Lieferanten umgegangen wird, erfordern.

Mit diesem CI-Bewußtsein können nun Verhalten, Kommunikation und Erscheinungsbild aufeinander abgestimmt werden. CD ohne CI (und damit ohne CC und CB) heißt, daß maximal 1/3 des optimal Möglichen erreicht wird.

Wie verhalte ich mich?

CB
Corporate
Behaviour

CI

Wie sehe ich aus?

CD
Corporate
Design

CC
Corporate
Communication

*Wie spreche ich?
Wie formuliere ich?*

CI vermitteln durch verbale Äußerungen

Will das Unternehmen glaubwürdig erscheinen, müssen die drei Elemente des CI-Mix (CD, CC, CB) aufeinander abgestimmt sein.

design
CATHARINE BRADBURY
art direction
CATHARINE BRADBURY
photography
LEESA STREIFLER
artwork
LEESA STREIFLER
firm
BRADBURY DESIGN
client
DUNLOP ART GALLERY

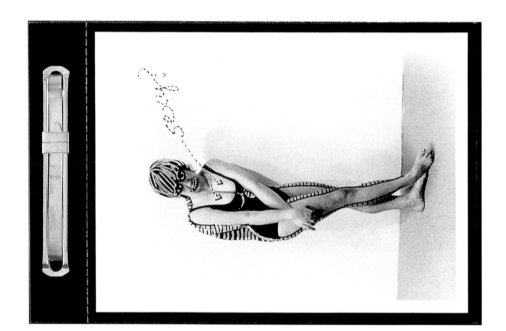

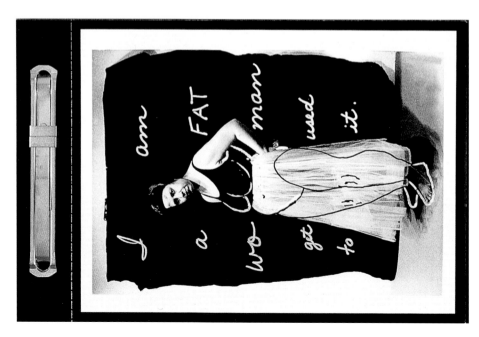

3 · 3 · 3 · Group Show 1996

VISION for NEW

QUEST

design
**FREEMAN LAU SIU HONG,
CHAU SO HING**

art direction
FREEMAN LAU SIU HONG

photography
C. K. WONG

firm
**KAN & LAU DESIGN
CONSULTANTS**

client
3.3.3 GROUP

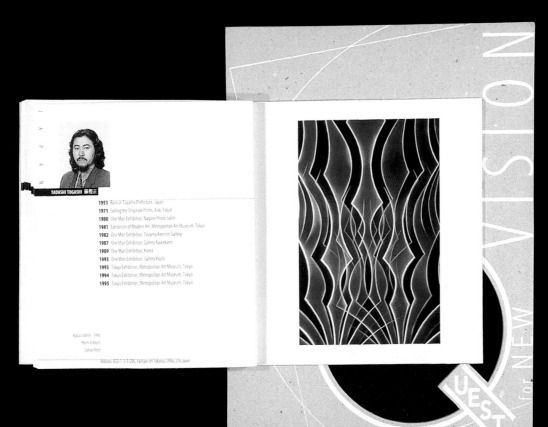

J A P A N

TADASHI TOGASHI 藤樫正

1951 Born in Toyama Prefecture, Japan
1971 Selling the Originale Prints, Aoki Tokyo
1980 One Man Exhibition, Nagase Photo Salon
1981 Exhibition of Modern Art, Metropolitan Art Museum, Tokyo
1982 One Man Exhibition, Toyama Kenmin Gallery
1987 One Man Exhibition, Gallery Kawakami
1989 One Man Exhibition, Korea
1993 One Man Exhibition, Gallery Kiichi
1993 Tokyo Exhibition, Metropolitan Art Museum, Tokyo
1994 Tokyo Exhibition, Metropolitan Art Museum, Tokyo
1995 Tokyo Exhibition, Metropolitan Art Museum, Tokyo

Hallucination 1996
90cm X 60cm
Colour Print

Address: 812-T-3-5-206, Yaichigo-05 Takatsu, Osaka, 776 Japan

VISION for NEW

QUEST

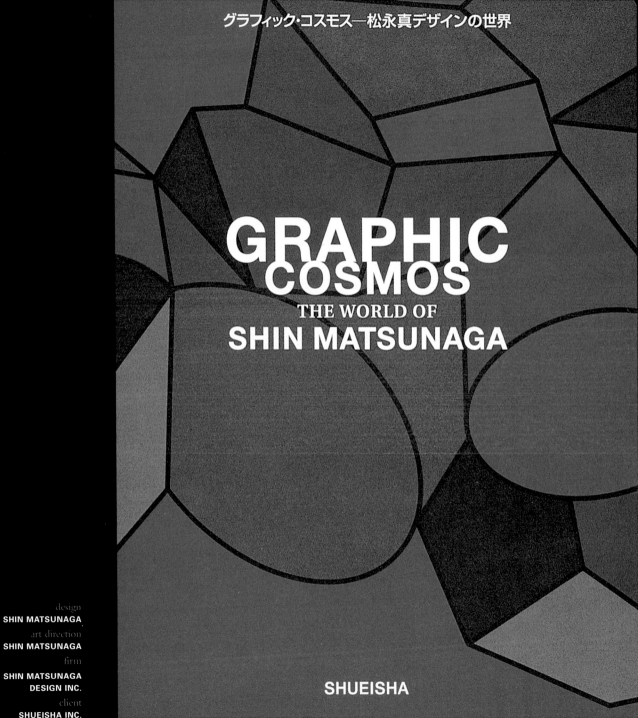

グラフィック・コスモス—松永真デザインの世界

GRAPHIC COSMOS
THE WORLD OF
SHIN MATSUNAGA

design
SHIN MATSUNAGA
art direction
SHIN MATSUNAGA
firm
SHIN MATSUNAGA
DESIGN INC.
client
SHUEISHA INC.

SHUEISHA

GOOD LIVING SHOW '91
APRIL 26—MAY 1, 1991, HARUMI TOKYO

ORCHESTRA FESTIVAL

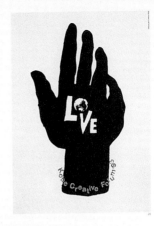

LOVE

Kobe Creative Forum '93

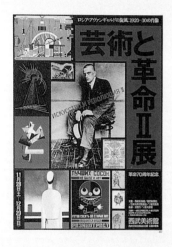

ロシア・アヴァンギャルドの旋風:1920-30の肖像

芸術と革命II展

革命70周年記念
西武美術館

マン・レイ展

Poliakoff

TADAO ANDO

BAUHAUS

ALLEGORY OF SEEING

MASTERPIECES FROM THE
GUGGENHEIM
COLLECTION
FROM PICASSO TO POLLOCK

タトル展

Poliakoff

Shaker Design

安井賞展

BRUNO TAUT
Nature and Fantasy

PETER VOULKOS

RICHARD TUTTLE
SELECTED WORKS:
1964

Individual Realities in the California Art Scene

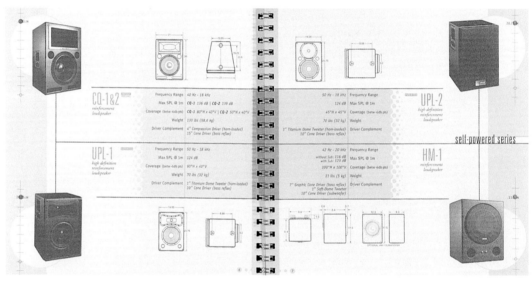

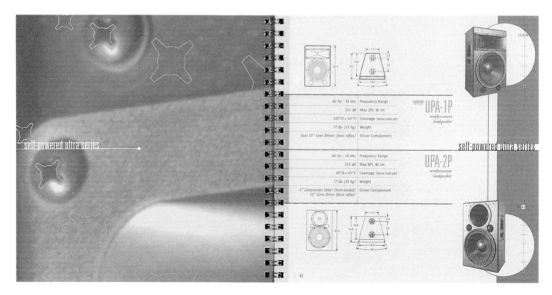

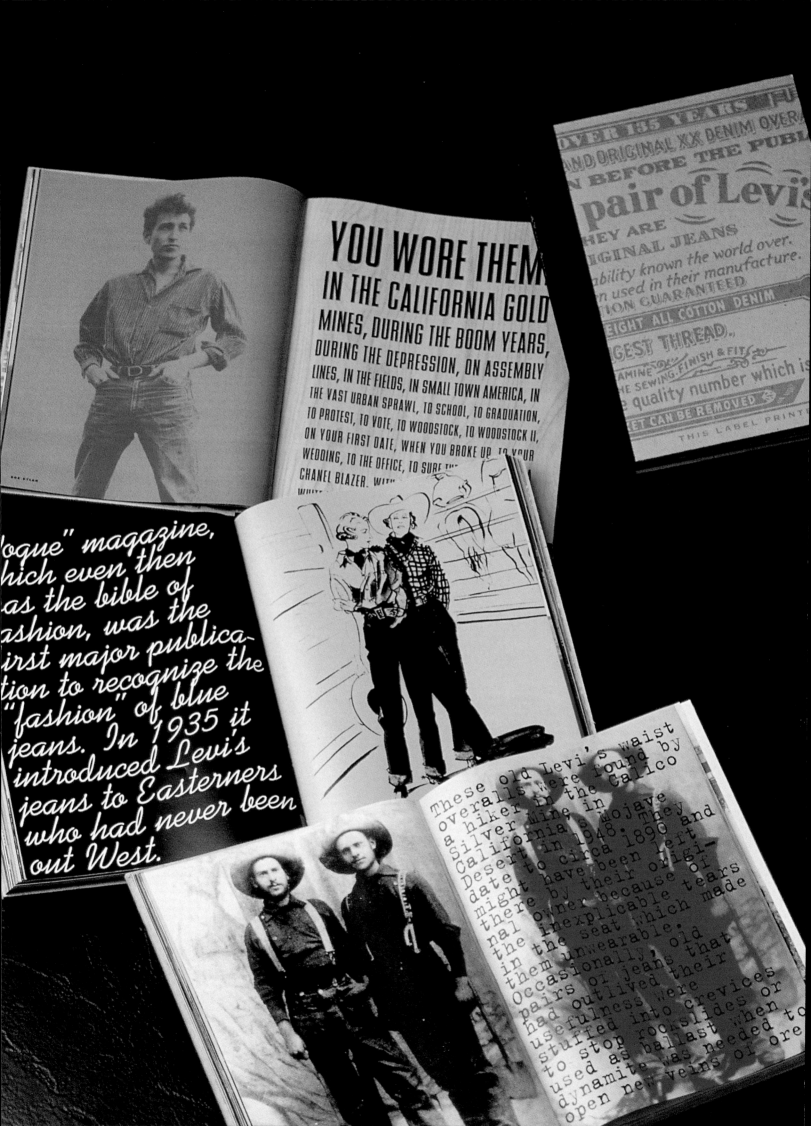

BOB DYLAN

YOU WORE THEM
IN THE CALIFORNIA GOLD
MINES, DURING THE BOOM YEARS, DURING THE DEPRESSION, ON ASSEMBLY LINES, IN THE FIELDS, IN SMALL TOWN AMERICA, IN THE VAST URBAN SPRAWL, TO SCHOOL, TO GRADUATION, TO PROTEST, TO VOTE, TO WOODSTOCK, TO WOODSTOCK II, ON YOUR FIRST DATE, WHEN YOU BROKE UP, TO YOUR WEDDING, TO THE OFFICE, TO SURF TH᠁ CHANEL BLAZER, WIT᠁

OVER 115 YEARS ᠁U᠁
AND ORIGINAL XX DENIM OVER᠁
᠁N BEFORE THE PUBLI᠁
pair of Levi's
᠁HEY ARE
᠁IGINAL JEANS
᠁ability known the world over.
᠁n used in their manufacture.
᠁ION GUARANTEED
᠁EIGHT ALL COTTON DENIM
᠁GEST THREAD.,
᠁AMINE ᠁ THE SEWING, FINISH & FIT
e quality number which i᠁
᠁ET CAN BE REMOVED ᠁
THIS LABEL PRINT᠁

'ogue" magazine, ᠁hich even then ᠁as the bible of ᠁ashion, was the ᠁irst major publica-᠁tion to recognize the "fashion" of blue jeans. In 1935 it introduced Levi's jeans to Easterners who had never been out West.

These old Levi's waist overalls were found by a hiker in the Calico Silver Mine in California's Mojave Desert in 1948. They date to circa 1890 and might have been left there by their origi- nal owner because of the inexplicable tears in the seat which made them unwearable. Occasionally, old pairs of jeans that had outlived their usefulness were stuffed into crevices to stop rockslides or used as ballast when dynamite was needed to open new veins of ore᠁

BREAKING THE RULES IN PUBLICATION DESIGN

maga

Style is a simple way of saying complicated things.
—Jean Cocteau

The root of "magazine" comes from the Arabic *makhazin* which means "storehouse." This is a fitting etymology, considering magazines house such a variety of images and information. From eclectic, eye-catching visuals to varied editorial content, magazines truly are repositories of abundant supply—and style.

While other types of publications typically have more clear-cut functional criteria and communicative objectives, magazines run the gamut in both areas. This absence of guidelines has given magazine designers the luxury of experimentation and creative latitude—and has rendered an exciting mix of visual presentations.

Says Hans Teensma, Art Director of Impress, Inc.: "Magazines run the gamut from serious to humorous, fiction to nonfiction, yet they're meant to be rolled up and put in the pocket."

Though they share the ephemeral quality of newspapers, magazines have fewer format constraints. The result is an unpredictability and flexibility not common in most publication design. Indeed, magazines are more likely to surprise than assuage. They can carry earnest editorial or humorous illustrations. They can dabble more in graphic experiment and less in aesthetic expectation. In short, magazine designers can make up the rules as they go along.

The magazine is prone to a certain kind of "disorder" in its design—a disorder that has surprising impact. Today, magazine designers are using techniques considered taboo in other publication media—layered images, unconventional texts, innovative blends of page elements, and outlandish typography, to name just a few. These modern twists can be attributed to both the medium's freedom as well as today's overall cultural and editorial climate—not to mention countless technological innovations.

Magazine design has certainly evolved over the last 20 years, but in the final analysis, the objectives are still the same. Both design and copy strive for the same goal: to tell a story or communicate a message simply and effectively.

"It all comes down to 'What do you want to do and where do you want to go?'" observes Teensma. "The tools have changed, and there's a lot of competition, but you still need to satisfy the reader. Playing with Photoshop can be fun, but the audience still needs to read it."

design
KATIE CRAIG
art direction
HANS TEENSMA
firm
IMPRESS, INC.
client
THE ORION SOCIETY

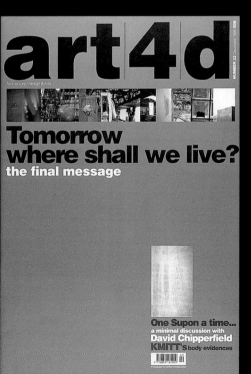

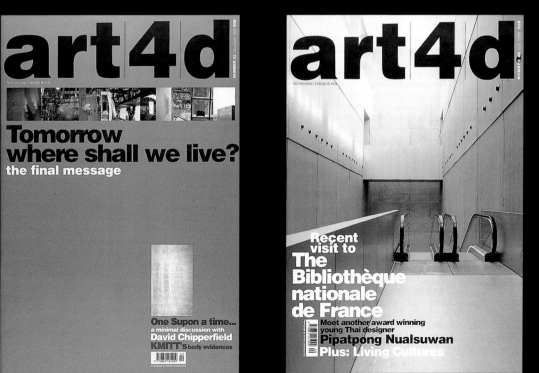

art editing
KRISSANA TANATANIT

photographic editing
**SOMKID PAIMPIYACHAT,
WISON TUNGTHUNYA,
PRUK DEJKHAMHAENG**

art assistance
**SARAWUT CHAROENNIMUANG,
WARARAT SONGKHUNTOD**

editor in chief
MONGKON PONGANUTREE

firm
ART 4D

client
ART 4D

BETRAYED

RUSSIA'S RETREAT FROM RELIGIOUS LIBERTY

On September 26, 1997, Russian Federation president Boris Yeltsin signed the widely publicized and highly controversial bill "On Freedom of Conscience and on Religious Associations." This law, which comprehensively regulates church-state relations in Russia, is hailed by supporters as a landmark provision that will protect Russia from intrusive and unwanted religions and even from the core of a new national ideology to replace the atheistic Marxist ideology of the Soviet era. Critics, however, charge that the new law denies freedom of conscience, violates international human rights declarations that Russia has signed, and promises only to perpetuate the tyranny over religion that characterized the Soviet period. Because of Russia's role as leader among a host of former Soviet and Soviet-bloc nations seeking to separate themselves from the yoke of Communism, the law is profoundly significant.

What does this new law say, and why has Russia adopted a public philosophy that rolls back much of its post-1990 experiment in religious liberty?

The 1990 Law on Religion and Its Effects

Russia's new law on religion is a retreat from its "Freedom of Conscience and Religious Organizations," passed on October 1, 1990. That revolutionary law, passed in the liberal spirit of perestroika ("restructuring") and glasnost ("openness"), made "all denominations and religions . . . equal under the law," and guaranteed every citizen's right to "freedom of conscience." It declared Russia to be a secular state, prohibited the establishment of a state religion, and denied to the state any right of intervention in religious affairs. Churches and other religious organizations were permitted to freely engage in worship and mission activities, operate schools and seminaries, own property, and publish and distribute religious literature, all without the requirement of registering with the government.

The 1990 law actualized Russia's desire to usher in religious freedom. Almost overnight Russia experienced a phenomenal resurgence of faith. The Russian Orthodox cathedrals, which in many cases had been converted to commercial use or made into museums during the Soviet era, were opened and soon filled with worshippers. Other traditional religions, such as Islam, Buddhism, shamanism, and Old Believers (a branch of Russian Orthodoxy) experienced renewal. Christian churches, including Catholic, Baptist, Methodist, Lutheran, Seventh-day Adventist, and Pentecostal, along with nontraditional groups such as Hare Krishna, the Great White Brotherhood, the Church of Scientology, the Mother of God Center, became a part of everyday life. Evangelists and missionaries from the West entered the country in surprisingly large numbers, and religious crusades, often nationally televised, became commonplace. The variety and intensity of religious expression on Russian soil was unprecedented.

Meanwhile, the Russian Federation, after years of planning, adopted a new constitution in 1993. A democratic document in every way, the constitution explicitly guaranteed basic civil and religious rights. Article II boldly declared that "the human being, his rights and freedoms shall be the supreme values of the Russian Federation," and therefore, "it shall be the duty of the state to recognize, respect, and protect the inviolable interests" of the citizen. Moreover, it specifically called for a "secular state" in which all "religious associations shall be separated from the state, and shall be equal before the law," and guaranteed the "equality of all persons . . . on account of religion." The new climate of religious freedom in Russia seemed secure.

Derek H. Davis (B.A., M.A., J.D., Baylor University; Ph.D., University of Texas at Dallas) is director of the J.M. Dawson Institute of Church-State Studies, Baylor University, and editor of Journal of Church and State.

BY DEREK H. DAVIS

ILLUSTRATION BY JEFFREY L. DEVER

LIBERTY JULY/AUGUST 1998 25

design
JEFFREY L. DEVER

art direction
JEFFREY L. DEVER
EMILY MARTIN KENDALL

illustration
JEFFREY L. DEVER

electronic production
ANNE HART

firm
DEVER DESIGNS

client
LIBERTY MAGAZINE

LARRY MILLER ON INNOVATION AND TRANSITION

LARRY

MILLER

LARRY MILLER'S INNOVATIVE IDEAS AS A CONSULTANT AND AUTHOR HAVE HELPED DEFINE QUALITY MANAGEMENT AND WHOLE-SYSTEM ARCHITECTURE. His books, *American Spirit: Visions of a New Corporate Culture* and *Barbarians to Bureaucrats: Corporate Life Cycle Strategies*, show us how corporate America — and especially management — has evolved into a third era where quality, change, and leadership take on new meaning. We spoke recently with Larry at the Atlanta headquarters of his firm, The Miller Consulting Group. His views on the new age of business we are entering — and how management needs to think and act differently in this period of transition — provide some new insights into the increasingly complex world of business.

PHOTOGRAPHY BY PHILIP BEKKER

SPRING 1998 ISSUE

design
SUSIE MCQUIDDY

art direction
WILLIAM L. JOHNSON

photography
PHILIP BEKKER

firm
PRESSLEY JACOBS DESIGN

client
WATSON WYATT WORLDWIDE

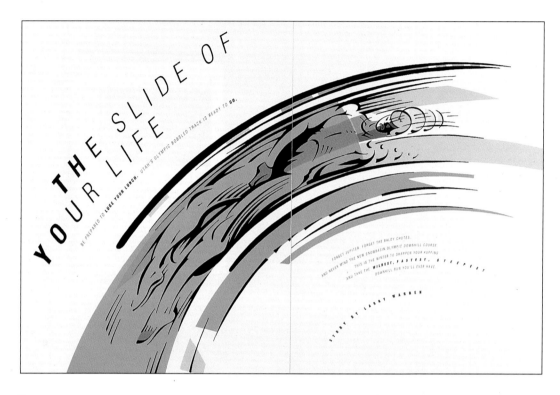

THE SLIDE OF YOUR LIFE

BE PREPARED TO **LUGE YOUR LUNCH.** UTAH'S OLYMPIC BOBSLED TRACK IS READY TO **GO.**

FORGET JUPITER. FORGET THE BALDY CHUTES.
AND NEVER MIND THE NEW SNOWBASIN OLYMPIC DOWNHILL COURSE.
THIS IS THE WINTER TO SHARPEN YOUR HUFFING
AND TAKE THE **WILDEST, FASTEST, STEEPEST**
DOWNHILL RUN YOU'LL EVER HAVE.

STORY BY LARRY WARREN

design
CHA CHA WELLER, DON WELLER
art direction
CHA CHA WELLER, DON WELLER
illustration
DON WELLER
firm
THE WELLER INSTITUTE FOR THE CURE OF DESIGN
client
PARK CITY LODESTAR

Personal Financial Education Moves to Center Stage

With the Health Care Reform Act, employee benefits has become front-page news. But while the nation has its eyes planted on page one and the health care situation, another employee benefits issue may be moving from a concern to crisis stage.

The latest annual estimates of the viability of the Social Security system has the system going bankrupt by the year 2036, down from the 2063 estimates made in 1983. Without the foundation of a strong Social Security system, we once again are left to wonder who will pick up the tab for retirement.

In years past, employers shouldered the burden. But not today; not with slim profit margins, the global marketplace, increased competition, and the recent chipping away of tax advantages for employer-sponsored retirement plans (see TEFRA, TRA '86, OBRA '87, and OBRA '93). In fact, the Pension Benefit Guaranty Corporation estimates that the gap between benefits promised and assets in the 50 most underfunded pension plans increased 30% to $38 billion. Now, more and more employers are shifting part of the responsibility to employees, moving retirement benefits away from entitlements to supplements.

31 WYATT COMMUNICATOR

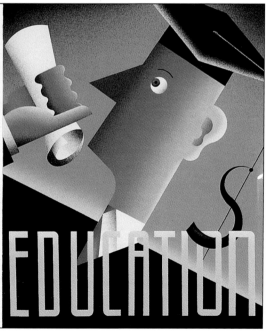

EDUCATION

design
SUSIE MCQUIDDY
art direction
SUSIE MCQUIDDY
illustration
TERRY ALLEN
firm
PRESSLEY JACOBS DESIGN
client
WATSON WYATT WORLDWIDE

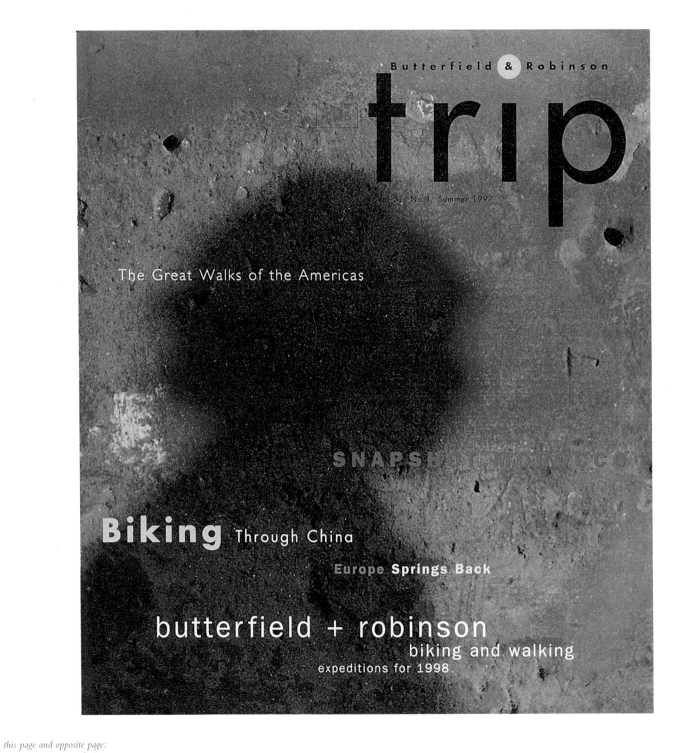

Butterfield & Robinson

trip

Vol 31 · No 1 · Summer 1997

The Great Walks of the Americas

Biking Through China

Europe **Springs Back**

butterfield + robinson
biking and walking
expeditions for 1998

this page and opposite page:
design
FRANK VIVA

art direction
FRANK VIVA

photography
CHARLIE SCOTT

firm
VIVA DOLAN
COMMUNICATIONS & DESIGN

client
BUTTERFIELD & ROBINSON

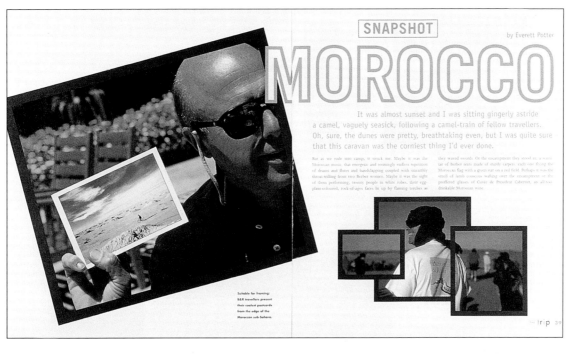

SNAPSHOT

by Everett Potter

MOROCCO

It was almost sunset and I was sitting gingerly astride a camel, vaguely seasick, following a camel-train of fellow travellers. Oh, sure, the dunes were pretty, breathtaking even, but I was quite sure that this caravan was the corniest thing I'd ever done.

But as we rode into camp, it struck me. Maybe it was the Moroccan music, that energetic and seemingly endless repetition of drums and flutes and handclapping coupled with unearthly throat-trilling from two Berber women. Maybe it was the sight of them performing, twenty people in white robes, their egg-plant-coloured, rock-of-ages faces lit up by flaming torches as they waved swords. Or the encampment they stood in, a warren tar of Berber tents made of sturdy carpets, each one flying the Moroccan flag with a green star on a red field. Perhaps it was the smell of lamb couscous wafting over the encampment or the proffered glasses of Cuvée de Président Cabernet, an all too drinkable Moroccan wine.

Suitable for framing:
B&R travellers present
their coolest postcards
from the edge of the
Moroccan sub-Sahara.

Trip 39

A Journey Among the Maya

TRAVELLER'S journal

Butterfield & Robinson's exploration of Belize has always included an overnight journey into neighbouring Guatemala to see the magnificent Mayan ruins at Tikal. Then last season, following the advice of B&R travellers and our own research team, we expanded the scope of the trip to include a stay in Antigua, the original capital of Guatemala. Set in the highlands and ringed by three volcanoes, Antigua is one of Latin America's most beautiful cities. Its historic legacy of universities, convents, monasteries and aristocrats' mansions includes some of the most impressive and authentic examples of Spanish colonial architecture in the New World. Here B&R walkers stroll cobbled streets past 16thC churches, exploring hidden courtyards and markets filled with superb native crafts. There are further walks between villages on the slopes of dormant Volcán Agua before we catch a private charter flight north to Flores and make the brief journey overland to Tikal. At this point the story is picked up by an old friend of B&R, writer and broadcaster Marian Botsford Fraser. A former president of PEN Canada, the Canadian branch of the international writers' organization that fights for freedom of expression (and a favourite cause of B&R), Marian is a seasoned cultural and social affairs journalist whose travel writings include the book *Walking the Line*, her first-person account of a journey along the 5,500-mile border between Canada and the U.S. She offers these key scenes from the Belize & Guatemala Walking Expedition.

Life@Work

BLENDING BIBLICAL WISDOM AND BUSINESS EXCELLENCE

JULY 1998, VOL. 1, NO. 2, $7.95

ONE DEFINITION

FOUR CATEGORIES

SEVEN PROFILES

& ONE INTERVIEW

WITH

[failure]

design
TIM WALKER

art direction
TIM WALKER

photography
MARK JACKSON

firm
WALKER CREATIVE, INC.

client
THE LIFE@WORK CO.

REACH FOR A GOBLET BY VALERI TIMOFEEV AND MARVEL at its exquisite workmanship and Old World beauty. Stand before a teapot by Sergei Isupov and feel your insides tighten as your brain works its way around surreal, often shocking imagery. Approach a Martin Rosol sculpture and feel the strength of its crystal, light-capturing spaces.

By
LEE LAWRENCE

Artists UNBOUND

These works, as varied in medium as in style, spring from the hands of artists who came of age behind the Iron Curtain and have since made their homes—and studios—in the United States. They belong to a group that is creating new and exciting patterns in the tapestry that is the American art world, where cultures have throughout our history variously intersected, melded, coexisted and clashed.

"These artists," says Kenneth Trapp, curator-in-charge of the Renwick Gallery in Washington, D.C., "are infusing American craft with a wonderful spirit, new imagery and new traditions," which are, he adds, "unsettling," in the way all true change is.

Eastern European émigrés celebrate artistic freedom with works of great beauty and striking imagery

Lee Lawrence spent four years in the former Yugoslavia, delving into the art scene and learning the "codespeak" that Communism engendered. She lives in Washington, D.C.

Patrick Matveev defines "Nature," his ceramic and fiberglass undulate, as an abstract expression of the struggle against oppression.

Sergei Isupov creates surreal teapots as vehicles for expressing emotional states. With "Involuntary Cycle," left, he comments on hidden desires, terminating the glazed flesh-tones of a female figure with the matte gray of a grasping shadow figure.

Zeimsur Chazsarde crafts 14ink, haunting faces on his sterling silver and patina click pins, opposite page.

46 • AMERICANSTYLE WINTER 1997

design
JEFFREY L. DEVER

art direction
JEFFREY L. DEVER

production
HOLLY HAGEN

firm
DEVER DESIGNS

client
THE ROSEN GROUP—AMERICAN STYLE

design
ELICIA TAYLOR
illustration
ELICIA TAYLOR
firm
BOELTS BROS.
client
TUCSON ARTS DISTRICT

design
KERRY STRATFORD
illustration
KERRY STRATFORD
firm
BOELTS BROS.
client
TUCSON ARTS DISTRICT

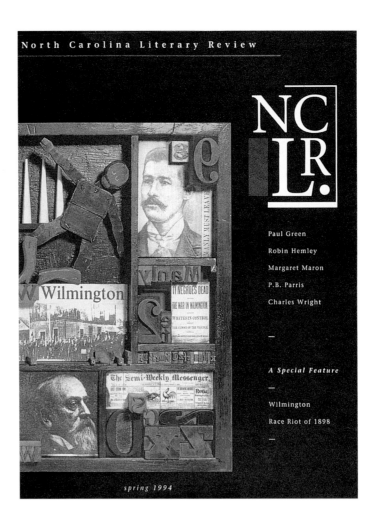

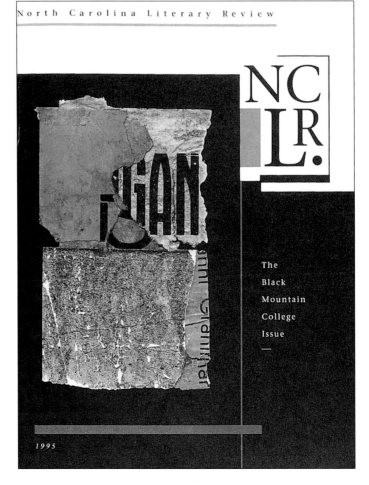

this page and opposite page:
design
EVA ROBERTS,
STANTON BLAKESLEE
art direction
EVA ROBERTS,
STANTON BLAKESLEE
editing
ALEX ALBRIGHT
cover art (bottom)
IRWIN KREMEN
cover illustration (top)
RAY ELMORE
cover photography (top)
PHILIP A. BURZYNSKI
firm
EAST CAROLINA UNIVERSITY
SCHOOL OF ART
client
ECU ENGLISH DEPARTMENT

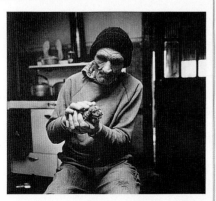

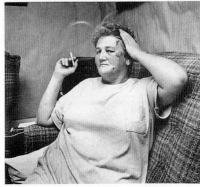

Rockingham County's Neugents have, for the most part, clung to the traditions of the tenant farmer: solidarity with the land, and resentment for city folks and big landowners. Mamie Neugent's father farmed tobacco, like his father before him, and became a landowner. But her late husband, Tracy Neugent, spent most of his working life farming tobacco on shares or in public work; not until he had reached old age did the family buy their own farmland.

When I began photographing the Neugents, my approach, as a documentary photographer, was typical of the American genre of photojournalism; the Neugents were treated as objects to be photographed by my camera. Because I had been a photojournalist, I thought about what I might do to change this approach, as I wanted to make these images more intimate, more empathetic; I wanted to move more into their world. Time seemed to be the primary ingredient necessary to make this leap; by allowing more time, the Neugents began to trust me, and more intimate photo possibilities began to emerge.

As I worked with these new goals in mind, the

BREAKING THE RULES IN PUBLICATION DESIGN

newsl

Conciseness is the sister of talent.

—Anton Chekhov

Synergy

The official biannual magazine of the Office of Building

OFFICE OF BUILDING

Few publications offer the ephemeral and compact quality of newsletters. Whether weekly, monthly, or quarterly, they thrive on timeliness and immediacy. Their communicative goals are precise and customized; their design solutions fast and deadline-driven. Indeed, newsletters are meant to be browsed, flipped through... and discarded.

Such a fleeting life span yields a different approach from graphic designers. "It's shorter and there's less content, so there's more time to concentrate on design," contends Tim Walker of Walker Creative. "I enjoy the fact that it's so concise. It gives you more of an opportunity to experiment."

Although newsletters are often considered low on the "desirability" scale of graphic design, such pieces enjoy unique advantages. Compared to newspapers or magazines, newsletters are easier to produce. Given their very nature, there are fewer type, picture, and color challenges. Furthermore, newsletters are cheaper and less complicated to publish. This can be an asset for companies (especially nonprofits) with tighter budgets.

Still, newsletters enjoy some of the same functional and aesthetic options as their publication siblings. Today's newsletter designers have numerous ingredients to consider: diverse grids, flashy type treatments, conceptual illustrations, and various paper stocks, to name just a few. The skilled designer is the one who can determine which of these elements to include—and exclude—and how to blend them in the most compelling and meaningful ways.

Technology has drastically influenced the newsletter production process. Today's designers are much more knowledgeable of computer capabilities, and that has translated into inventive typography and fresh layout treatments. The digital revolution, however, can both free and inhibit designers. The key is not to allow computers to create visual redundancy.

According to Walker, it's important not to use technology as a crutch for newsletter design. "Digital technology can be dangerous. You can't allow those tools to create your design parameters," says Walker. "Whatever the technology is, design principles are unchanging. Great design is still based on the same premises."

What is the key to effective newsletter design? The answer is three-fold: Take advantage of its ephemeral qualities, play up its immediacy, and optimize the concise content. Because combining photos, design, illustrations, and writing must be done so quickly, newsletters usually render an unexpected look and feel.

ATM Multimedia Through Your Meridian 1?

IT'S JUST AROUND THE CORNER.

Nortel's' amazing Meridian 1' continues to evolve, this time to give you multimedia communications through your PBX using state-of-the-art Asynchronous Transfer Mode (ATM) switching technology.

ATM switching fabric in your PBX brings you a host of benefits – more call carrying capacity, completely non-blocking architecture, simpler

installation, increased levels of redundancy, and all current features and functionalities. It can also smoothly handle your migration to high-speed multimedia communication. ATM technology lets you consolidate multiple voice, data and video networks onto a single, powerful, integrated network, then deliver multimedia capabilities throughout your entire "local" network environment.

Testing, 1, 2, 3...
At Nortel, we just completed two technical trials between Meridian 1's using the ATM switching fabric. Our Santa Clara, California facility worked with Yale University (a long-time Nortel customer) to complete the first-ever transcontinental call between ATM-switched PBXs. Another trial, between the offices of the Societe Internationale de

Telecommunications Aeronautiques (SITA) and EQUANT in Nice, France and the Santa Clara facility and Yale University, resulted in the first-ever transatlantic call between ATM-based PBXs.

"The engineering trial switch is a viable bridge from the telephony of today to next-generation Internet telephony," said John Meickle, director of planning and technology at Yale ITS Telecommunications.

"It preserves existing Meridian 1 features and dependability...while opening up the ability to support future integrated voice and data applications."

► (cont'd on page 6)

N⊘RTEL
MERIDIAN TELECOM

Year 2000 Compatibility –

WE'RE GEARED UP TO MEET THE 21ST CENTURY

It's one of those true communications challenges. During the next three years, virtually every computer and software system in the world must be upgraded to handle dates after the turn of the century.

Why?
It started in the early years of computing. Software programmers had to conserve then-scarce memory and processing, so they used two-character rather than four-character dates. This practice became the standard.

Today the industry is painfully aware that when we enter the year 2000, many systems will not be able to distinguish between 2000 and 1900 since both end with "00." This has major implications for systems that rely extensively on dates – for example, banking systems that compute interest due on accounts. So, we in the industry must change all standard two-character dates to three- or four-character dates.

And this particular turn-of-the-century event carries an even greater challenge. The year 2000 is a leap year, a century-turning event that happens once every 400 years. The system must be able to effortlessly compute dates figuring in all the calculations of a leap year. So, to operate effectively, every system must be made year 2000 compatible.

Technically, it's not a problem.
The solution is simple, but not easy. That is, we have the technology to easily fix the problem. The hard part is the time-consuming task of reading ►
(cont'd on page 2)

N⊘RTEL

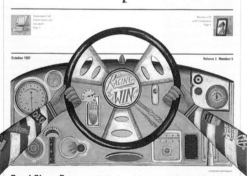

Road Show Revs Up With Nortel Power Networks

Ladies and gentlemen, start your engines. The 1997 Fall Road Show blasts over the starting line October 22, with a blistering tour of 30 cities, featuring the hottest hardware and software developments for the Meridian 1' product line.

This year's day-long presentation, Power Networks': Racing to Win, shows how Nortel Power Networks and our new Symposium' multimedia

portfolio of products can help you blow past your competition. Just ask the folks at the Indy Racing League, whose new, fully integrated, comprehensive Nortel Power Network consistently puts them in the winner's circle.

Ready, Set, Go!
At the Road Show, the checkered flag goes down at 8:00 a.m. with a continental breakfast. The General Session revs up at 8:30, with presentations on Power Networks, Symposium, Meridian 1 and new product announcements.

Before joining us for lunch, you can attend the first of three workshop sessions. A total of six workshops from which to choose run simultaneously throughout the day. And at each workshop, our pit crews are standing by, ready to answer your questions.

If you're looking into powering your business, check out the Digital Switching workshop – everything you always wanted to know about Meridian 1, Passport', Concierge and Norstar', the world's best-selling system for small business.

In the market for a call center? Then don't miss the Multimedia I ►
(cont'd on page 2)

N⊘RTEL

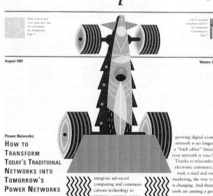

Power Networks:

HOW TO TRANSFORM TODAY'S TRADITIONAL NETWORKS INTO TOMORROW'S POWER NETWORKS

Today, companies who want a competitive advantage in their business are seizing it with Nortel (Northern Telecom) Power Networks?

Power Networks allows you to transform Nortel's traditional multiple business networks into a single, powerful, integrated multimedia network. Power Networks are faster, simpler and more secure, reliable and cost-effective than traditional networks. Power Networks

integrate advanced computing and communications technology to improve customer service, cut operating costs and put a world of information at your fingertips.

Why You Need a Power Network for Tomorrow's Business
As more of your business is transacted on the network and the demand for new applications, speed, and capacity escalates, your network becomes absolutely vital. With our

growing digital economy, the network is no longer simply a "back office" function – your network is your business. Thanks to teleconferencing, electronic commerce, voice mail, e-mail and one-to-one marketing, the way you work is changing. And these business tools are putting a growing strain on your network, and traditional networks are struggling to keep up. This means the gap between the power you need and what your network can deliver continually widens. To close this gap, companies rely on Nortel's Power Networks – networks that include digital switching, multimedia applications, Internet/ intranet solutions, mobility solutions and Wide Area Network (WAN). ►
(cont'd on page 2)

N⊘RTEL

design
JONATHAN INGRAM
art direction
WILLIE BARONET
firm
GIBBSBARONET
client
NORTEL

design
JACKSON BOELTS
art direction
JACKSON BOELTS
illustration
JACKSON BOELTS
photography
JACKSON BOELTS
firm
BOELTS BROS. ASSOCIATES
client
TUCSON ARTS DISTRICT

design
ERIC BOELTS
art direction
ERIC BOELTS
firm
BOELTS BROS. ASSOCIATES
client
TUCSON ARTS DISTRICT

this page:
design
**CHUCK JOHNSON,
KEN KOESTER,
ROB SMITH**

art direction
**CHUCK JOHNSON,
KEN KOESTER,
ROB SMITH**

creative direction
CHUCK JOHNSON

illustration
**CHUCK JOHNSON,
KEN KOESTER,
ROB SMITH**

photography
**JACK UNRUH,
DICK PATRICK,
KENT KIRKLEY**

firm
BRAINSTORM

client
**DALLAS SOCIETY OF
VISUAL COMMUNICATIONS**

opposite page:
design
**CHUCK JOHNSON,
ART GARCIA,
WAYNE GEYER**

art direction
**CHUCK JOHNSON,
ART GARCIA,
WAYNE GEYER**

illustration
**CHUCK JOHNSON,
ART GARCIA,
WAYNE GEYER**

photography
**ABEL SANCHEZ,
DOUG DAVIS,
NEIL WHITLOCK,
DOUG HOPFER**

creative direction
CHUCK JOHNSON

firm
BRAINSTORM

client
**DALLAS SOCIETY OF
VISUAL COMMUNICATIONS**

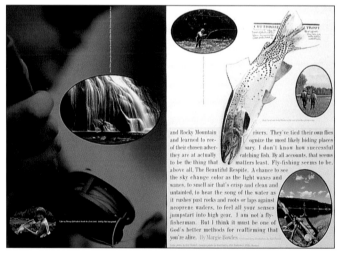

ROSS
PEROT
DOESN'T
LIVE
HERE
ANYMORE

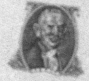

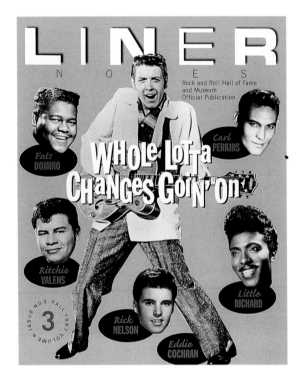

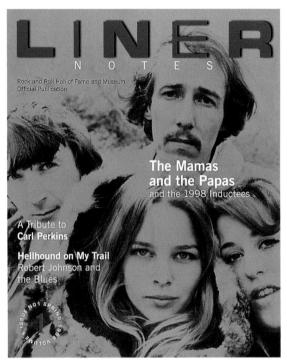

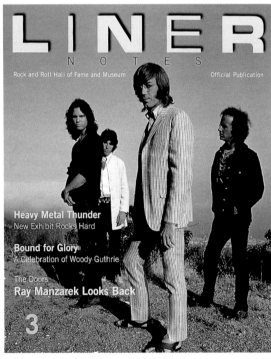

design
TIMOTHY LACHINA

art direction
**MARK SCHWARTZ,
TIMOTHY LACHINA**

firm
NESNADNY + SCHWARTZ

client
**ROCK AND ROLL HALL OF
FAME AND MUSEUM**

The Rock and Roll Hall of Fame's 1996 inductees are a diverse group whose music ranges from soul to psychedelia. This year's class includes folk music hero Pete Seeger as an early influence, and radio innovator Tom Donahue in the non-performer category, along with performers David Bowie, Gladys Knight and the Pips, Jefferson Airplane, Little Willie John, Pink Floyd, the Shirelles and the Velvet Underground.

David Bowie has made a career of changes, pioneering—then discarding—musical styles and personas with a dizzying frequency. He mastered glam-rock with works like "Ziggy Stardust," then turned into a soul stylist with "Young Americans," a funk rocker with "Golden Years" and "Fame," and a dance club fixture with "Let's Dance," with stops at the early roots of art rock and punk rock along the way. Bowie is an adventurous and original artist.

Gladys Knight and the Pips are one of the outstanding female-led groups of the rock and roll era. A family act that began performing at church functions, Gladys Knight and the Pips rose to prominence after signing to Motown in 1966, scoring hits spanning four decades, including "I Heard It Through the Grapevine," "Every Beat of My Heart," "Neither One of Us (Wants to be the First to Say Goodbye)," and their biggest hit, "Midnight Train to Georgia."

Jefferson Airplane epitomized the sound of San Francisco at its experimental, song-oriented best with its soul, blues and folk-influenced psychedelic rock. The band's commercial success, with such Top Ten songs as "White Rabbit" and "Somebody To Love," allowed it wide latitude for experimentation, and the Jefferson Airplane pushed hard at the boundaries of rock and roll.

Little Willie John, whose career flourished in the mid-1950s, was a master of rhythm & blues ballads. John scored his first hit with "All Around the World," and went on to record other R&B hits, such as "Talk to Me, Talk to Me," and "Sleep," his highest-charting single. He also co-wrote and was the first to record "Fever," a song covered by talents as diverse as Peggy Lee and Madonna.

It was to describe Pink Floyd that the term "underground rock" was coined by the British press in 1967. Beginning as a trailblazing psychedelic band, the group went on to a long and influential career, creating masterpieces such as Dark Side

of the Moon, which stayed on the Top 200 charts for a record-breaking 741 weeks, and The Wall, the band's epic about alienation and isolation.

Formed when its members were still in high school in New Jersey in 1957, the Shirelles are the great pioneers of the infectious "girl group" sound. The group had a string of hits between 1958 and 1962, with their first, "I Met Him On a Sunday," followed by "Tonight's the Night," "Will You Love Me Tomorrow" and "Soldier Boy."

It is often said that the Velvet Underground never sold a lot of records, but every person who

bought one started a band. Fronted by Lou Reed and discovered by Andy Warhol, the Velvets surveyed the raw edges of society in songs such as "Sweet Jane" and "Rock and Roll." Their view of modern life inspired groups such as R.E.M., U2, Pearl Jam, the Jesus and Mary Chain, David Bowie, Talking Heads and Sonic Youth.

Pete Seeger wrote or co-wrote classics of the American songbook, including "Goodnight Irene," "Where Have All the Flowers Gone?" and "If I Had a Hammer." He has been an inspiration to generations of audiences and musicians, including Bob Dylan and the Byrds.

The late disc jockey Tom Donahue is considered the father of progressive FM radio. As a San Francisco DJ in the late 1960s, Donahue invented "free form" radio and revolutionized radio broadcasting in the United States. He rebelled against the rigid Top 40 format, and encouraged on-air personalities to play a wide variety of music, from rock and blues to jazz and soul.

On the cover: David Bowie
Clockwise from upper left:
Tom Donahue, Syd Barrett,
Pink Floyd, Gladys Knight
and the Pips; Jefferson
Airplane, the Shirelles, the
Velvet Underground, Little
Willie John, Pete Seeger.

The Rock and Roll Hall of Fame Foundation was established to honor rock and roll's most significant artists and their work. Artists become eligible for induction 25 years after the release of their first record. The nominating process begins with an annual committee meeting of several dozen rock and roll experts of widely varying tastes and experience. The committee eventually develops a list of about 15 eligible artists, which is then submitted to an international voting body of nearly 1,000 women and men from all walks of rock and roll life. Of the 15, five to seven make the final cut and are inducted into the Rock and Roll Hall of Fame. In addition, the Nominating Committee selects inductees in the categories of early Influences and non-performers. Watch future Liner Notes for a complete list of the 131 inductees.

Bang Your Head
Three Decades of Hard Rock and Heavy Metal

Anger, anxiety insecurity, loneliness and sexual confusion—

sounds like just another Saturday night in the life of teenage America.

Not surprisingly, these also sound like the themes most often found in the kind of driving, pounding hard rock that is alternately labeled heavy metal, heavy rock or even "head-banging" music. Finding its core audience among teenage boys, the many stylistic shades within this broad category have another central theme: if it's too loud, you're too old.

While hard rock constantly re-emerges on the pop music scene (Metallica's headlining of the concert extravaganza Lollapalooza and Kiss' return to touring are but two recent examples), it reached its widest audiences during the early 1970s, with groups such as Led Zeppelin, Black Sabbath and Deep Purple.

Bang Your Head, a new exhibition opening September 20 at the Rock and Roll Hall of Fame and Museum, traces this music from its antecedents in blues-based power rock in the 1960s to its commercial dominance in the 1970s, to 1990s practitioners such as Metallica. Many of these hard rockers are among popular music's most outlandish performers, employing stage costumes and props that draw from myths, mysticism and, sometimes, mayhem. The style's theatrical presentation is abundantly evident in this colorful exhibition.

Among the highlights of Bang Your Head: a pair of working cannons used on stage by AC/DC in the 1980s, as well as a church bell from the group's Back in Black tour, and Angus Young's schoolboy outfit. Original artwork for the Motörhead album "Sacrifice," An electric chair stage prop used by Iron Maiden.

A cross used by Mötley Crüe for the group's 1989 Dr. Feelgood tour. A customized, 1982 Harley Davidson low rider, used on stage by Rob Halford of Judas Priest in the 1980s. Dee Snider's gender-bending stage costume—complete with wig, shoulder pads and fringed boots—used in the Twisted Sister video "We're Not Gonna Take It," and on the Stay Hungry tour in 1984.

A stable of leather costumes, from the metal-studded S&M Judas Priest stage outfit, to Ted Nugent's loincloth. The exhibit also contains a black leather jacket with flashing fiber optic lights worn by Iron Maiden's Bruce Dickinson in 1986, Slash's (of Guns N' Roses) black leather jacket and trademark top hat (above) from the mid-1980s, and the black leather jacket worn by Black Sabbath's Tony Iommi in 1971.

The main weapon of hard rock's arsenal has always been the electric guitar, and Bang Your Head will display an impressive collection, including Ted Nugent's Gibson semi-hollow body (below), the Gibson Flying V used by Ozzy Osbourne's guitarist Randy Rhoads, and the Fender Stratocaster used by Ritchie Blackmore of Deep Purple, among others. The exhibition also contains two bass guitars: a vintage Gibson EB-1 from Felix Pappalardi of hard rock pioneers Mountain and Lemmy's (of Motörhead) Rickenbacker bass.

Born to be Wild will be on display on the Museum's fourth floor into the spring of 1997.

By Jeff Hagan

Above: Metallica. Center, left to right: Phil Collen of Def Leppard, Bela Lugosi, guitar, Slash of Guns N' Roses, black leather jacket. Lemmy of Motörhead, Rickenbacker bass. Below: AC/DC.

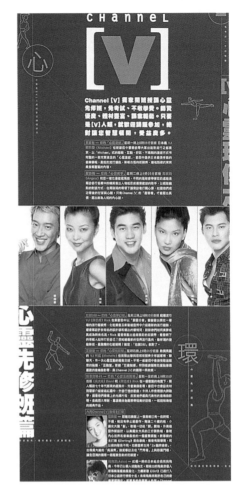

design
CATHERINE LAM SIU HUNG
art direction
CATHERINE LAM SIU HUNG
creative direction
MANI RAO
firm
**SATELLITE TELEVISION
ASIAN REGION LTD**
client
CHANNEL [V]

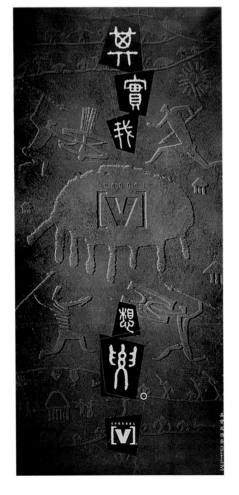

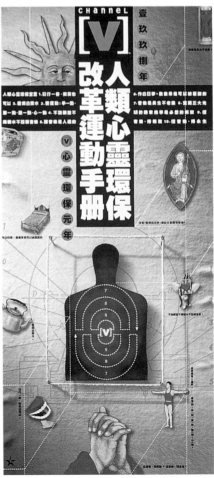

design
**CHUCK JOHNSON,
KEN KOESTER,
ROB SMITH**

art direction
**CHUCK JOHNSON,
KEN KOESTER,
ROB SMITH**

illustration
**CHUCK JOHNSON,
KEN KOESTER,
ROB SMITH**

photography
**PETE LACKER,
KEITH BARDIN,
GREG WATERMANN**

creative direction
CHUCK JOHNSON

firm
BRAINSTORM

client
**DALLAS SOCIETY OF
VISUAL COMMUNICATIONS**

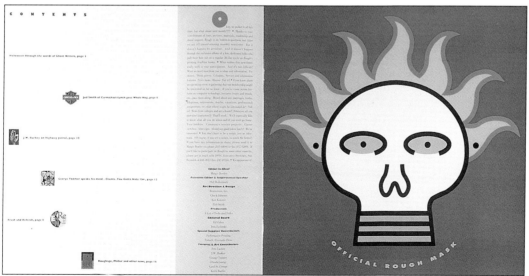

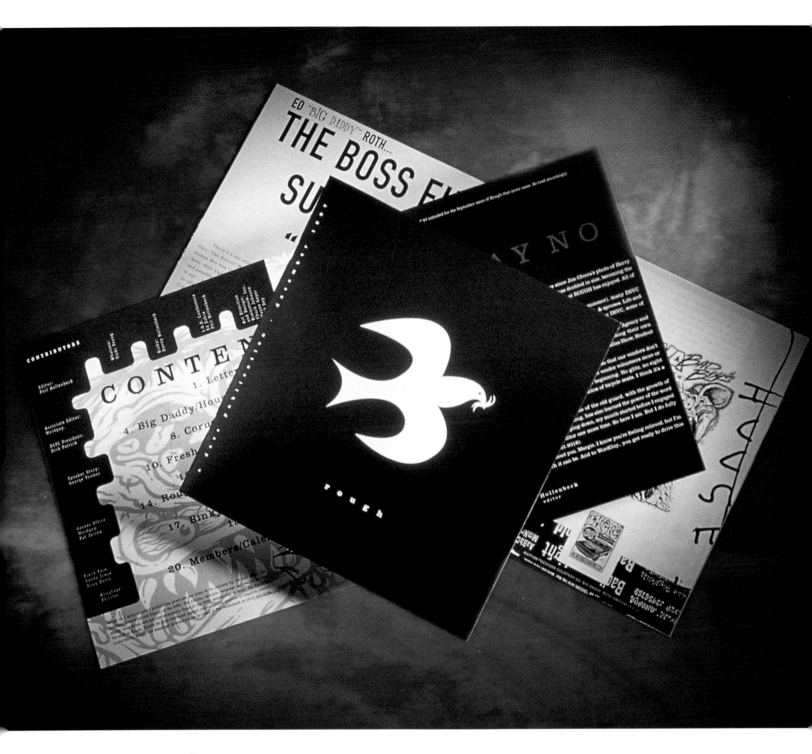

design
**CHUCK JOHNSON,
JEFF DEY, WAYNE GEYER**

art direction
**CHUCK JOHNSON,
JEFF DEY, WAYNE GEYER**

illustration
**BIG DADDY ED ROTH,
CHUCK JOHNSON**

photography
**PHIL HOLLENBECK,
DANNY HOLLENBECK,
DOUG DAVIS**

creative direction
CHUCK JOHNSON

firm
BRAINSTORM

client
**DALLAS SOCIETY OF
VISUAL COMMUNICATIONS**

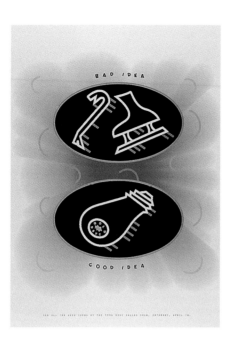

design
CHUCK JOHNSON,
KEN KOESTER, ROB SMITH

art direction
CHUCK JOHNSON,
KEN KOESTER, ROB SMITH

illustration
CHUCK JOHNSON,
KEN KOESTER, ROB SMITH

photography
JACK UNRUH,
DICK PATRICK,
KENT KIRKLEY

creative direction
CHUCK JOHNSON

firm
BRAINSTORM

client
DALLAS SOCIETY OF
VISUAL COMMUNICATIONS

Hundreds of students expose themselves.

update

"Fulfilling the Promise" Campaign Ends in Success

The four-year fund-raising campaign for Scripps Clinic and Research Foundation and The Scripps Research Institute has surpassed its $140 million goal.

"Fulfilling the Promise: The Campaign for Scripps Clinic and Scripps Research Institute" had received more than $143 million in gifts and pledges on June 30, 1993, the campaign's official date of completion. An additional $45 million in expected bequests were also made known to Scripps during the campaign. (See list of major contributors on page 12.)

The effort was the largest capital campaign ever attempted by a nonprofit organization in San Diego County. More than 14,000 donors made gifts ranging from five dollars to $8 million. Thirty-two individuals, foundations and businesses contributed $1 million or more; seventeen of them are located in San Diego County.

The funds committed have been earmarked for research, patient care, education, land acquisition, expansion of facilities, and the permanent endowment fund.

"This campaign was a substantial accomplishment for our community—the Scripps Clinic and Scripps Research Institute

(continued on page 5)

Scripps Educates Bioscience Leaders

As The Scripps Research Institute further evolves into an organization with few equals worldwide, one key element of its growing mission will be education—both of its own aspiring scientists (the graduate programs help to integrate the disciplines of cell and molecular biology, structure and chemistry) and of those in the community. The following stories describe some of the Research Institute's expanding educational efforts. (continued on page 2)

2
TSRI:
Ph.D. programs
granted accreditation

9
Creating Health:
Guidelines for
vitamin supplements

16
Coming Up:
Exercise to Swing and
Big Band music

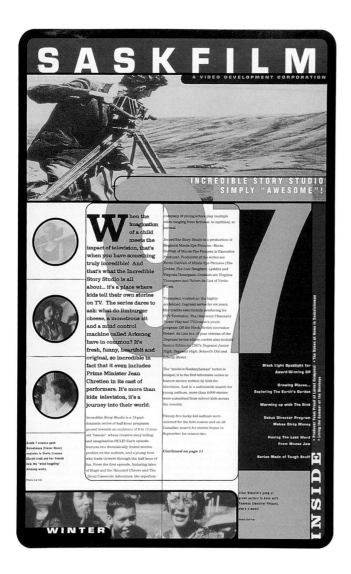

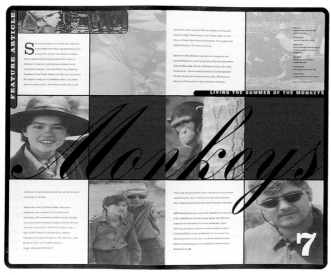

design
CATHARINE BRADBURY
art direction
CATHARINE BRADBURY
firm
BRADBURY DESIGN
client
**SASKFILM & VIDEO
DEVELOPMENT CORPORATION**

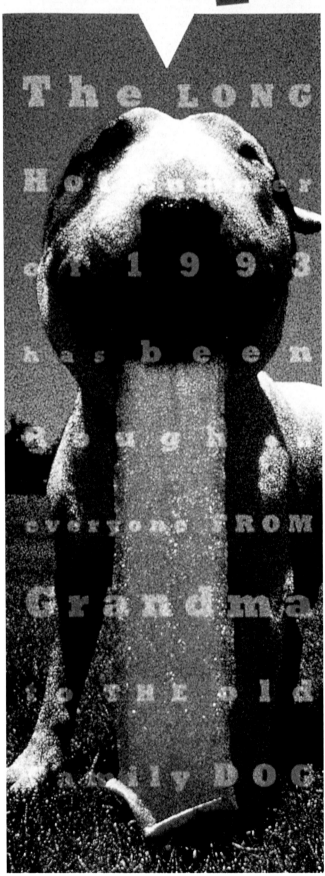

design
CHUCK JOHNSON,
KEN KOESTER, ROB SMITH
art direction
CHUCK JOHNSON,
KEN KOESTER, ROB SMITH
illustration
CHUCK JOHNSON,
KEN KOESTER, ROB SMITH
creative direction
CHUCK JOHNSON
firm
BRAINSTORM
client
DALLAS SOCIETY OF
VISUAL COMMUNICATIONS

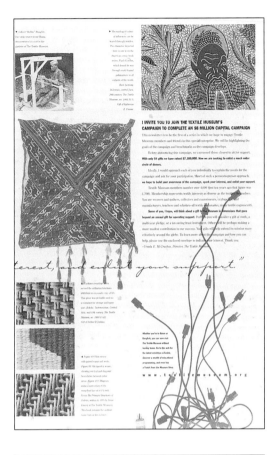

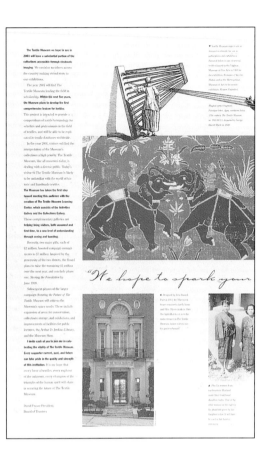

I INVITE YOU TO JOIN THE TEXTILE MUSEUM'S
CAMPAIGN TO COMPLETE AN $8 MILLION CAPITAL CAMPAIGN

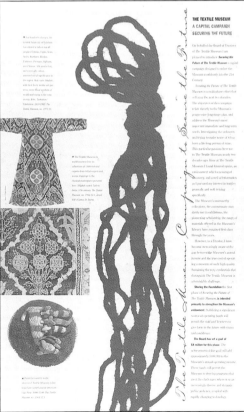

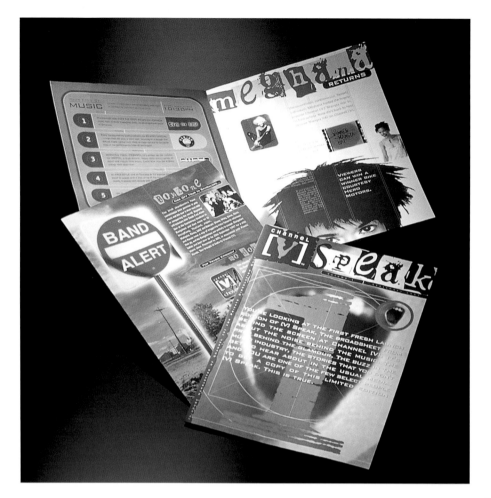

design
STUART WOOD
art direction
MANI RAO
creative direction
MANI RAO
firm
**SATELLITE TELEVISION
ASIAN REGION LTD**
client
CHANNEL [V]

design
CATHERINE LAM SIU HUNG
art direction
CATHERINE LAM SIU HUNG
creative direction
MANI RAO
firm
**SATELLITE TELEVISION
ASIAN REGION LTD**
client
CHANNEL [V]

A Publication of the Dallas Society of Visual Communications · November 1985 · Volume Three · Issue Number Three · Five Dollars

ROUGH

design
**CHUCK JOHNSON,
KEN KOESTER, ROB SMITH**
art direction
**CHUCK JOHNSON,
KEN KOESTER, ROB SMITH**
illustration
CHUCK JOHNSON,

design
CORNWELL DESIGN PTY LTD
art direction
STEVEN CORNWELL
firm
CORNWELL DESIGN PTY LTD
client
D & D PRINTING

design
**CHUCK JOHNSON,
KEN KOESTER, ROB SMITH**
art direction
**CHUCK JOHNSON,
KEN KOESTER, ROB SMITH**
photography
PHIL HOLLENBECK
illustration
**CHUCK JOHNSON,
KEN KOESTER, ROB SMITH**
creative direction
CHUCK JOHNSON
firm
BRAINSTORM
client
**DALLAS SOCIETY OF
VISUAL COMMUNICATIONS**

But there's more to the story. In recent years, information technology has been advancing at a breakneck pace, making more information available and bringing powerful new ways to use it. Now, many businesses are scrambling to improve the ways they manage their information, knowing their competition is doing the same. To help our customers meet this challenge, we're evolving, keeping the best of our best and making substantial improvements for the future.

A higher goal. An important part of our evolution is a higher goal for our business.

OUR MISSION

A commitment to your success.

A new identity.

EDITORIAL CONTACTS:

Microformas builds a new business in CD SOLUTIONS

success

Advances in information technology solutions are helping businesses in every industry meet new challenges

"Now that we are able to do CD production of higher volume, it has become a valuable part of our overall business."

a message from the CEO

W

Inside
Information

SCENARIOS FOR **success**	THE YEAR **2000**	DID YOU **know**	BERTRAND ON **trends**
Microformas, S.A., of Mexico has expanded its customer services by building a new high-volume CD production business from the ground up. 3	With the year 2000 rapidly approaching, here's a way to reduce the risk of information loss from the millennium bug. 4	High capacity, rapid access, and low cost all make CD an ideal medium for data storage and distribution applications. 4	Industry expert Ron Bertrand outlines the major trends that are shaping the world of information management systems. 6

ANACOMP: THE NEXT CHAPTER

As information technology advances, we're evolving to help you succeed.

We are beginning a new chapter in the Anacomp story. If you've been following the story, you know us as a company with three decades of experience providing information delivery solutions, a company with thousands of customers who rely on us as they face the challenges of the information age. (continued on next page)

ANACOMP

trends what's d... the m...

By Ron Bertrand

Most organizations today are overwhelmed by the challenge. Their individual users are either starved for to do their job or overwhelmed by stacks of informa...

...cognized as a world leader in ...s. But we've been expanding ...on delivery solutions in recent ...d, integrated line of solutions ...ation throughout its life cycle. ...ts and services we offer today.

COM systems and services.

Electronic delivery.

Magnetic media.

Technical services.

WORKING SMARTER WITH ANACOMP

A new addition to the Anacomp family is helping businesses make better use of their information through expert consulting in information management and process innovation.

- Improve how you access and use information.
- Reduce the time and resources you spend on storage and retrieval.
- Reduce manually intensive and paper-based processes.
- Improve the integrity of your information.
- Improve the productivity of your personnel.
- Enhance the flexibility of your options to meet changing needs.

new alliances bring new solutions

design
DEBORAH HOM
art direction
JOHN BALL
illustration
TRACY SABIN
photography
**JOHN STILL,
MICHAEL CAMPOS**
writing
**DANNIEL WHITE,
STEVE MILLER**
firm
MIRES DESIGN, INC.
client

design
**CHUCK JOHNSON,
WAYNE GEYER, JEFF DEY**
art direction
**CHUCK JOHNSON,
WAYNE GEYER, JEFF DEY**
illustration
**CHUCK JOHNSON,
WAYNE GEYER, JEFF DEY**
photography
**PHIL HOLLENBECK,
DOUG DAVIS,
STEVE MCALASTER**
creative direction
CHUCK JOHNSON
firm
BRAINSTORM
client
**DALLAS SOCIETY OF
VISUAL COMMUNICATIONS**

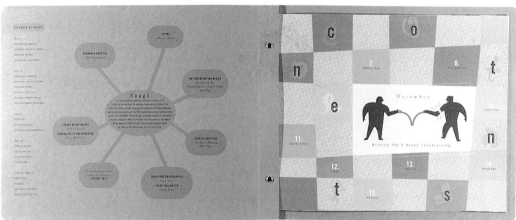

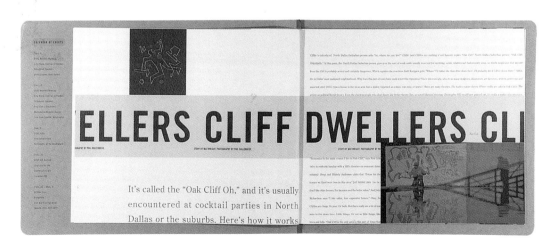

design
CORNWELL DESIGN PTY LTD
art direction
STEVEN CORNWELL
firm
CORNWELL DESIGN PTY. LTD.
client
OFFICE OF BUILDING

A Recruitment Newsletter
from the University of Arkansas
Fayetteville

arkansas travels

UNIVERSITY OF ARKANSAS STUDENTS ARE ON THE ROAD TO SUCCESS!

Accomplishments of our 1998 graduates have gained them admission and scholarship support for graduate programs at Harvard Law School, Stanford University's College of Engineering, and Oxford University. Two of our students were named to this year's USA Today's College All-Academic Team. A Fulbright Honors Program student majoring in French and music is the youngest person ever accepted by the Opera Institute to perform in the Rome Festival. One of our computer science majors was featured in Computer World magazine as a prodigy. There are many more success stories here. You, we hope, will become one of them.

U of A freshmen this fall are accepting the challenge to continue the tradition of success and to move the University ahead as the model land-grant university. The top 20% of our freshmen have an average ACT of 30 and an average grade point average of 3.9. These students will continue to benefit from the challenges that our faculty put before them so they can continue to compete nationally for the best internships, co-op, fellowships, and study abroad opportunities.

I hope that our recruitment team and this series of news updates will convince you to visit the campus and feel the exciting momentum that is occurring here. Our students and faculty are among the best in the nation. We would like for you to join the U of A community and the legacy of these success stories.

Let me know how we can help you with your important decision.

Maribeth Lynes
Director of Recruitment

A NEW VISION

changing admission standards at THE UNIVERSITY OF ARKANSAS

You may have heard things are changing at the University of Arkansas – and it's true. With the leadership of Chancellor John White, our vision for the 21st century is to be recognized among the best institutions in the nation for our excellent students, faculty, research, and campus resources. One of our first steps toward this lofty goal is to create a body of students who have demonstrated they are prepared for the challenge of earning a U of A degree; so, we have changed the way we will admit our students.

In past years, we used only the grade point average as the deciding factor for admission. While this method gave many students the opportunity to enter our doors, it was not the best way to determine whether each student was truly prepared to earn a college degree. We have found that a student's grade point average alone does not tell the whole story about their preparation for college success — we must review each applicant's entire record to make a better selection.

For fall 1999 admission and beyond, we will individually look at your wide range of achievements to determine whether you

have what it takes to earn a degree from the University of Arkansas. Here are all the factors we will consider as we evaluate your application for admission:

> High school course record and grade point average
> Standardized test scores (ACT or SAT)
> Letters of recommendation
> Special skills, talents, interests, volunteer work, community service, work experience, and honors and awards
> Academic and career goals

Typically, the higher your grade point average and test scores, the better your chances of succeeding and graduating at the University of Arkansas. To have the best possible chance of success here, you should have a B average (3.0) or higher and a score of no lower than a 20 on the ACT or 960 on the SAT. You should have completed the college preparatory core courses in high school. Your awards, activities, work, and other experiences are also very important. They tell us about your interests, persistence, and ability to manage your time. All of these factors play an important part in determining if you are prepared for success at the University of Arkansas.

By now
you should have taken or be completing the following college preparatory courses

Course	Courses	Notes
English	4 courses or units	
Mathematics	3 courses or units (REQUIRED) 4 courses or units (RECOMMENDED)	chosen from algebra I, geometry, algebra II, trigonometry, pre calculus, and calculus
Social Studies	3 courses or units	
Natural Sciences	3 courses or units	two courses are to be chosen from biology, chemistry and physics laboratory courses
Electives	3 courses or units	chosen from English, oral communication, foreign languages, mathematics, natural sciences, social studies, and computer sciences
TOTAL	16 courses or units	

design
MARINA CANNON

art direction
TIM WALKER

photography
RUSSELL COTHREN

firm
WALKER CREATIVE, INC.

client
UNIVERSITY OF ARKANSAS

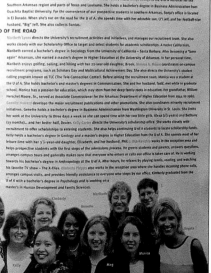

MEET our recruitment team

As University of Arkansas recruiters, our job is to learn as much as we can about you so we can match our opportunities with your needs. Well, we thought it might be interesting for you to know a little about us. Here are some of the people you may meet at your high school or during a campus visit, and who you may speak with over the telephone when you call our office. Our backgrounds are varied and interesting – just like yours. The one thing we share in common is that we love talking about the U of A!

ON THE ROAD

KEEPING in touch

AT THE END OF THE ROAD

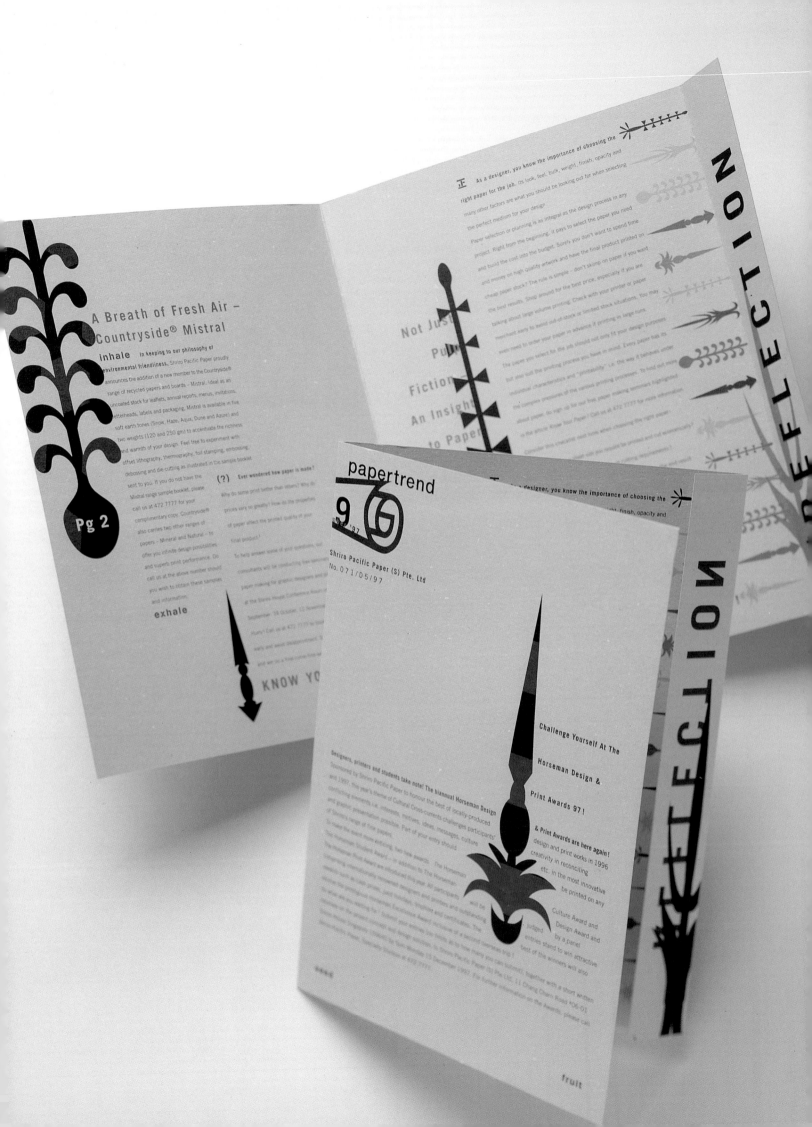

opposite page:
design
CHUNG YEW KEE
illustration
CHUNG YEW KEE
art direction
CHUNG YEW KEE
creative direction
CHUNG YEW KEE
firm
THE VERY GUNG-HO YEW KEE
client
**SHRIRO PACIFIC PAPER
SINGAPORE**

this page:
design
**CHUCK JOHNSON,
KEN KOESTER, LORI WALLS**
art direction
**CHUCK JOHNSON,
KEN KOESTER, LORI WALLS**
illustration
**CHUCK JOHNSON,
KEN KOESTER, LORI WALLS**
photography
**PHIL HOLLENBECK,
DICK PATRICK, DOUG DAVIS**
creative direction
CHUCK JOHNSON
firm
BRAINSTORM
client
**DALLAS SOCIETY OF
VISUAL COMMUNICATIONS**

M
SPA
AND SALON
at Mettlers

BREAKING THE RULES IN PUBLICATION DESIGN

collatera

pror

1989°

It's the hottest summer since 1976
Berlin Wall comes down
Radion launched by Lever Brothers
Interest rates go up to 15%
The sale of water shares is 5.7 times over subscribed
Thatcher celebrates 10 years as PM
House of Commons is televised
Sky TV is launched
Nigel Lawson resigns as Chancellor, John Major gets the job
The Sunday Correspondent is launched
Football suffers a tragedy at Hillsborough
New York Guardian Angels set up a branch in London
Students demonstrate in Tianamen Square
Railway strikes begin

Rules are what the artist breaks; the memorable
never emerged from a formula.
—Bill Bernbach

rom the nontraditionally packaged announcement to the whimsical flip-book invitation, this section is devoted to unforgettable promotional and collateral materials.

At its purest level, the promotional piece is unabashed and unrestricted advertising. The only rule is to make an impression that resonates. Whether conveying a corporate personality, a single idea, or a broader philosophy, promotional pieces inevitably strive to reflect charisma. Many companies throw caution—along with traditional design and packaging techniques—to the wind. This often translates into humor.

Case in point: Viva Dolan Communications & Design self-promo, "Let's Sell Ourselves!" (page 143). A disarming tale chronicling the history and philosophy of the design firm, the piece is sure to make a lasting impression on anyone who ventures to read it. Says art director Frank Viva, "We wanted to create a different and interesting keepsake, something that would have a long shelf life."

London-based design firm Springetts certainly made a splash in the sea of self-promotion for their 21st birthday (page 147). With bold and vibrant graphics, the piece is splashed with great moments in modern history. But even this seeminglyinnocent self-promo has a strategic angle. "Given that most of our clients are marketeers," explains managing director Peter Green, "we also managed to get in the odd famous marketing story."

Budget is a consideration in all publications, but promotions are often one area where dollars can really be saved. It is not unusual for paper companies or printers to absorb some of the production costs in exchange for a credit on the piece. Furthermore, some promotional pieces can function as everything from single-event announcements to holiday gifts to marketing pieces; such flexibility and versatility allow designers to get the best bang for the buck.

Whatever the budgetary considerations, the ultimate goal of publication design—especially promotional pieces—is to make such an impression that it lingers in the mind of the reader. And how does a designer know if that mission has been accomplished? Just ask Peter Green about the response to Springetts' self-promo. "We were delighted with the reaction of the book," says the design firm's managing director. "It has consistently achieved that holy grail of direct mail: kept and not thrown away!"

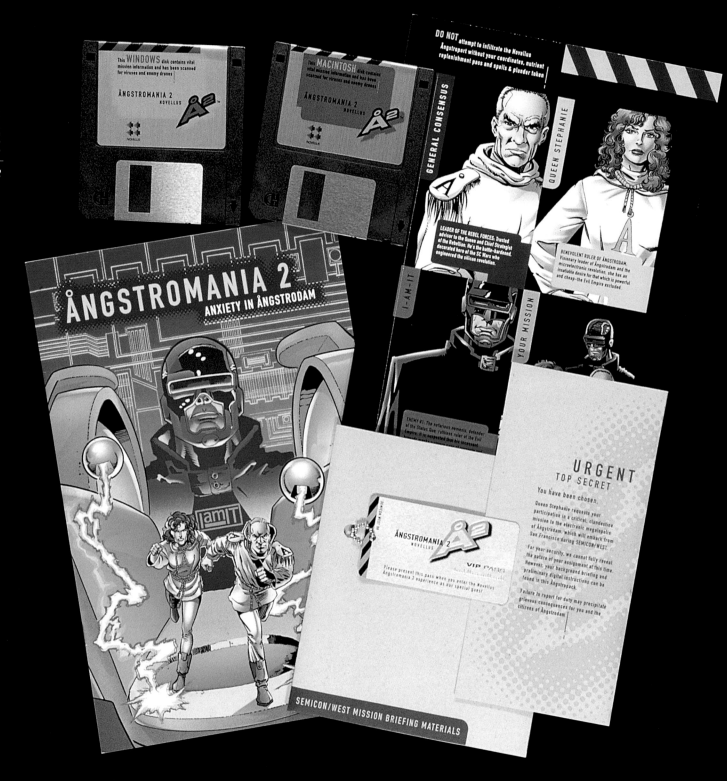

print design
**PETER DE SIBOUR,
SASCHA BOECKER**

interface design
**SEAN MCKAY,
JON WETTERSTEN**

art direction
DONNA ROOT

creative direction
TIM LARSEN

illustration
**DAN JURGENS,
JOE RUBINSTEIN**

lettering
RICHARD STARKINGS

writing
DAN JURGENS

printing
DIVERSIFIED GRAPHICS

firm
**LARSEN DESIGN +
INTERACTIVE**

client
NOVELLUS SYSTEMS, INC.

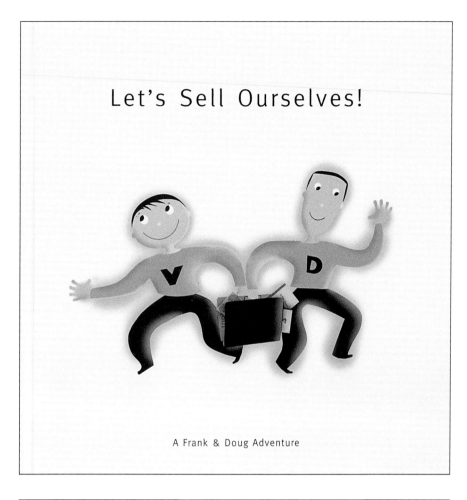

Let's Sell Ourselves!

A Frank & Doug Adventure

design
FRANK VIVA
art direction
FRANK VIVA
illustration
FRANK VIVA
writing
DOUG DOLAN
firm
**VIVA DOLAN
COMMUNICATIONS & DESIGN**
client
**VIVA DOLAN
COMMUNICATIONS & DESIGN**

One night as they locked their new office door, Frank said, "We need a way to sell ourselves, so people will ask us to make things for *them*."
"We could have a Viva Dolan Day at the ballpark," Doug suggested. Frank shook his head. "I don't think we have enough samples," he said. Just then Butterfield & Robinson, a company that takes people on biking and walking trips, asked the boys to make them a new catalogue.

The B&R work helped sell many trips. It won awards of gold, silver and other colors. Soon more clients wanted the Viva Dolan team to do the same kind of thing for them. Telephone companies, cruise lines, universities, law firms, software developers. Even a few tiny companies you could fit on the tip of one finger. But while the boys made their clients happy—or most of them, anyway—they never seemed to find time to sell themselves.

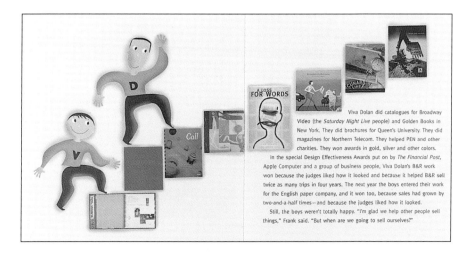

Viva Dolan did catalogues for Broadway Video (the *Saturday Night Live* people) and Golden Books in New York. They did brochures for Queen's University. They did magazines for Northern Telecom. They helped PEN and other charities. They won awards in gold, silver and other colors.
In the special Design Effectiveness Awards put on by *The Financial Post*, Apple Computer and a group of business people, Viva Dolan's B&R work won because the judges liked how it looked and because it helped B&R sell twice as many trips in four years. The next year the boys entered their work for the English paper company, and it won too, because sales had grown by two-and-a-half times—and because the judges liked how it looked.
Still, the boys weren't totally happy. "I'm glad we help other people sell things," Frank said. "But when are we going to sell ourselves?"

design
EMILY CAIN
art direction
LORI B. WILSON, EMILY CAIN
photography
TERRY VINE
firm
DAVID CARTER
DESIGN ASSOCIATES
client
DAVID CARTER

This time,
I am coming with
two **olive**
branches.

Yasir Arafat *quoted day of signing the Middle East Peace Pact, September 4, 1993*

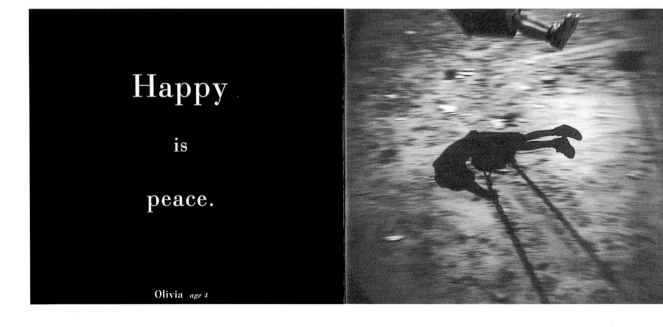

Happy

is

peace.

Olivia *age 4*

art direction
STEPHEN ELLIOTT

photography
PER ERICSON

firm
TWILIGHT STUDIOS

client
PER ERICSON

design
KOICHI SATO

art direction
KOICHI SATO

firm
**KOICHI SATO
DESIGN STUDIO**

client
**KAWASHIMA TEXTILE
MANUFACTURERS LTD.**

暗い風景としてのモノクローム

極限のモノトーン

design
NICKY SLOANE

art direction
PETE GREEN, ROGER BANNISTER

photography
GEORGE TAYLOR

firm
SPRINGETTS

client
SPRINGETTS

design
JEFF LARSON
art direction
**LANNY FRENCH,
DAVID EDELSTEIN**
photography
MICHAEL HABER
writing
PETER STOCKER
firm
FOUNDATION
client
TOMMY BAHAMA

when we finally made it outside, we found
the only gas station on the island who lent
us their 1965 Land Rover. For a buck of gas
in the Rover you can travel to a mango
grove. The best cheap date of your life.

Page Two: Weekend Camp. Shown in
Light Bleu. 100% silk. $78.00.
Plantation Pant. Shown in Oyster.
100% silk pique. $98.00.

Page Three: Vintage Palm Camp. Shown
in Aruba. 100% silk stripe dobby. $92.00. Surf
and Sand Short. Shown in Oregano.
100% cotton canvas. $48.00.

Page Five: Weekend Polo. Shown in
Dark Bean. 100% silk. $78.00. Casino
Deck Short. Shown in Khaki. 100%
silk herringbone. $65.00.

Page Seven: Garden of Eden Camp.
Shown in Light Femme. 100% silk.
$89.00. Bermuda Bermuda. Shown in
Oyster. 100% silk pique. $69.00.

Page Nine: Malibu Stripe Camp. Shown
in Khaki. 100% silk stripe
dobby. $80.00.

Page Ten: Regattaville Camp. Shown in
Khaki. 100% silk stripe dobby. $92.00.
Casino Deck Short. Shown in Almond.
100% silk herringbone. $65.00.

Page Eleven: Starburst Camp. Shown
in Black. 100% rayon. $56.00.
Bermuda Bermuda. Shown in Khaki.
100% silk pique. $69.00.

Page Twelve: Silly Lily Camp. Shown
in Khaki. 100% silk stripe dobby.
$59.00. Plantation Pant. Shown in
Black. 100% silk pique. $98.00.

All items available in additional colors. Her clothes, also by Tommy Bahama, available at select stores nationwide.

Italy
The Land of Wine

design
LO CHI MING
art direction
ERIC CHAN
illustration
LO CHI MING
firm
ERIC CHAN DESIGN CO. LTD.
client
ITALIAN TRADE COMMISSION

CA'VIT SCARL

Product 產品	**Pinot Grigio IGT "Cavit Collection"**
Color 色澤	
Aroma 香氣	
Flavor 味道	
Product 產品	**Chardonnay (La Bottega dei Vinai)**
Color 色澤	
Aroma 香氣	
Flavor 味道	
Product 產品	**Cabernet Sauvignon (La Bottega dei Vinai)**
Color 色澤	
Aroma 香氣	
Flavor 味道	
Product 產品	**Teroldego (I Mastri Vernacoli)**
Color 色澤	
Aroma 香氣	
Flavor 味道	
Product 產品	**Marzemino (Ziresi)**
Color 色澤	
Aroma 香氣	
Flavor 味道	
Product 產品	**Spumante Firmato Brut Millesimato**
Color 色澤	
Aroma 香氣	
Flavor 味道	

Company 公司名稱	CA'VIT SCARL
Address 地址	VIA DEL PONTE 31
	38040 LOC. RAVINA DI TRENTO (TN)
Tel 電話	461/981711
Fax 傳真	461/913540
E-mail 電子郵件	cavit@cavit.it
Website 網址	www.cavit.it
Contact 聯絡人	MR GIACINTO GIACOMINI - GENERAL DIRECTOR
Product 產品	Pinot Grigio IGT "Cavit Collection", Chardonnay (La Bottega dei Vinai), Cabernet Sauvignon (La Bottega dei Vinai), Teroldego (I Mastri Vernacoli), Marzemino (Ziresi), Spumante Firmato Brut Millesimato
Company Description 公司簡介	Cavit Cantina Viticoltori Scarl (The Group Co-operatives Cellars of Trentino), is a second degree co-operative cellar established in 1950 and located in Trento. Cavit with its expert technicians, wine makers and oenologists has direct and strict control both on harvesting the local grapes and the productive phase, as well as on selecting the grapes before making them into wine at the Growers Cooperative Cellars. After careful selection, the best wines of each cellar are sent to Cavit, which is dealing with marketing and trading them to major export markets in the world. Thanks to this organisation, Cavit is the most advanced in the development of the Trentino viticulture and oenolgy and can therefore offer the best DOC wine of Trentino.

Cavit 酒莊合作社於 1950 年在 Trento 成立。Cavit 集合多位專業釀酒學家及技術人員生產程序，由挑選及採摘葡萄至釀酒過程均經過嚴格的品質檢定。CAVIT 提供 Trentino 區的優質 DOC 酒以銷售世界各地。

design
GEORGE MARGARITIS
art direction
MARCUS LEE
illustration
GEORGE MARGARITIS
firm
MARCUS LEE DESIGN
client
AUSTRALIAN PAPER

design
**MARY JOHANNA BROWN,
CLAUDIA KAERNER,
BETSY BENNETT,
ALICEN BROWN,
STEVE COSTANZA, CHRIS LAMY,
BRIGHAM PENDLETON**
elvis impersonator
CHRIS HAMER
firm
**BROWN & COMPANY
GRAPHIC DESIGN**
client
**BROWN & COMPANY
GRAPHIC DESIGN**

design
CATHERINE LAM SIU HUNG
art direction
CATHERINE LAM SIU HUNG
illustration
LEE CHOW MING
creative services direction
BETHANY BUNNELL
firm
**SATELLITE TELEVISION
ASIAN REGION LTD**
client
STAR TV

design
JOSEPH FOO

firm
**TRINITY VISUAL
COMMUNICATIONS**

client
**MALAYSIA WETLAND
SANCTUARY**

design
QUENTIN TANG

art direction
QUENTIN TANG

creative direction
MANI RAO

head of design
CATHERINE LAM SIU HUNG

firm
SATELLITE TELEVISION
ASIAN REGION LTD

client
STAR TV

this page:
design
FRANZ KUTTELWASCHER
art direction
FRANZ KUTTELWASCHER
photography
H. P. SCHREIER
firm
KUTTELWASCHER WERBUNG
client
HOTEL AUSTRIA, LECH

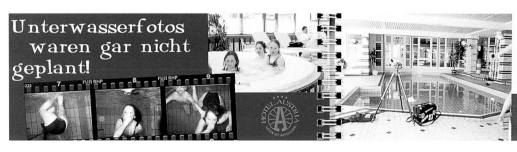

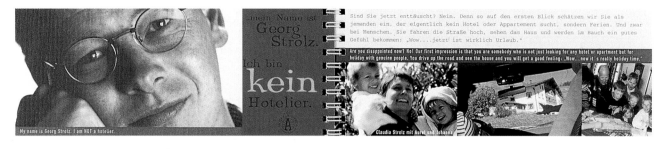

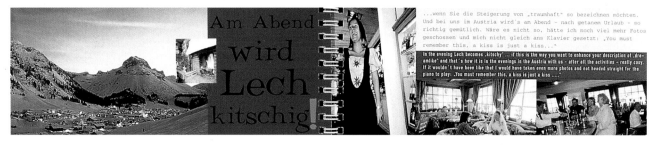

opposite page:
design
EVAN KUZ
art direction
EVAN KUZ
photography
TONY NARDELLA
copywriter
JOHN ALCOCK
firm
IDEA MARKETING GROUP
client
UNISOURCE PAPERS

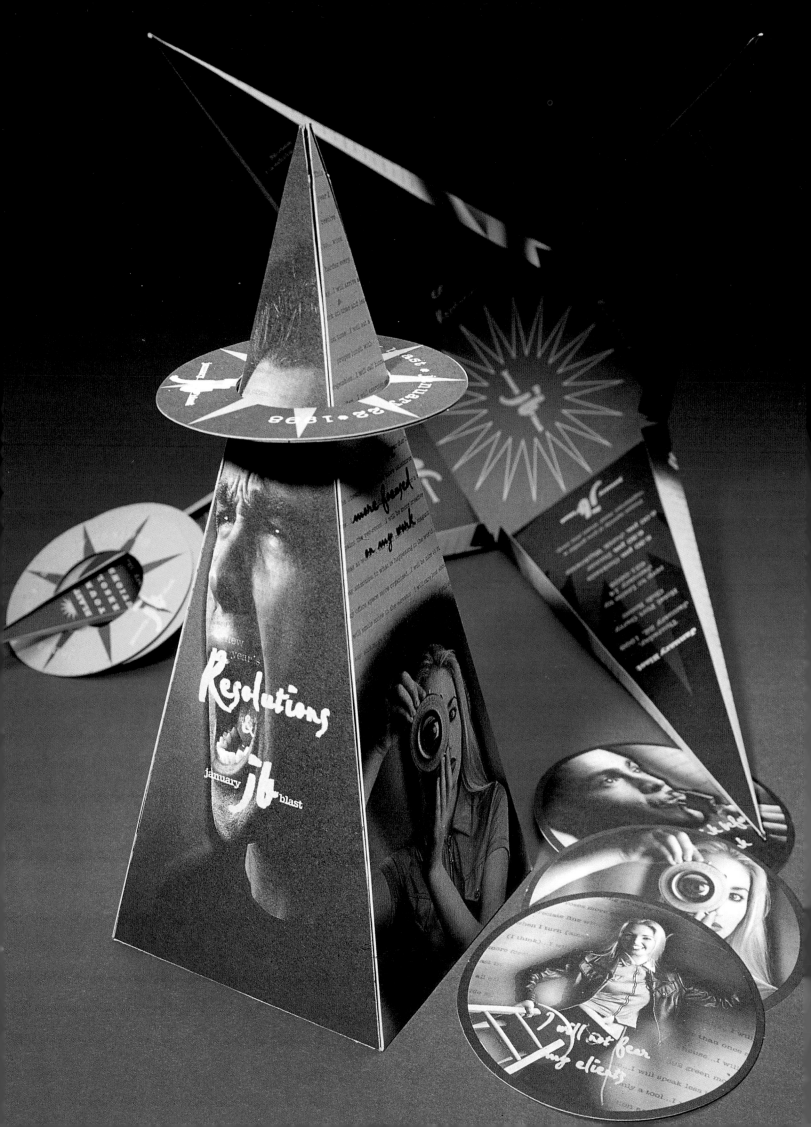

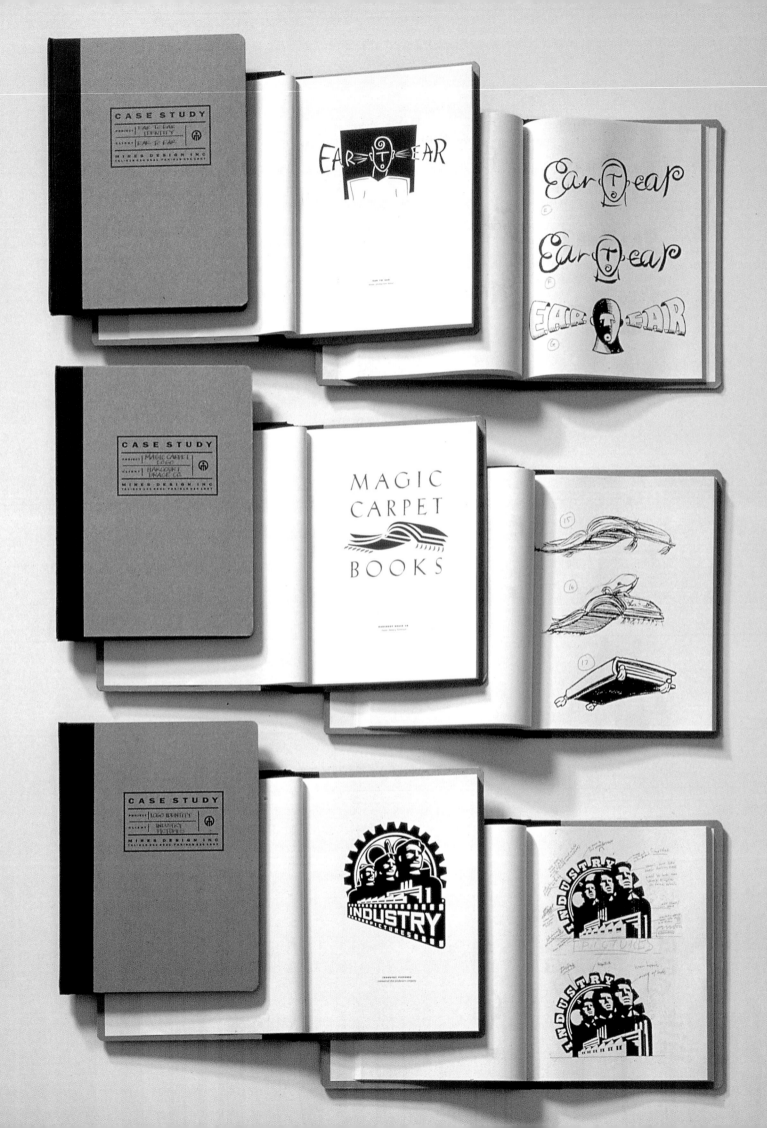

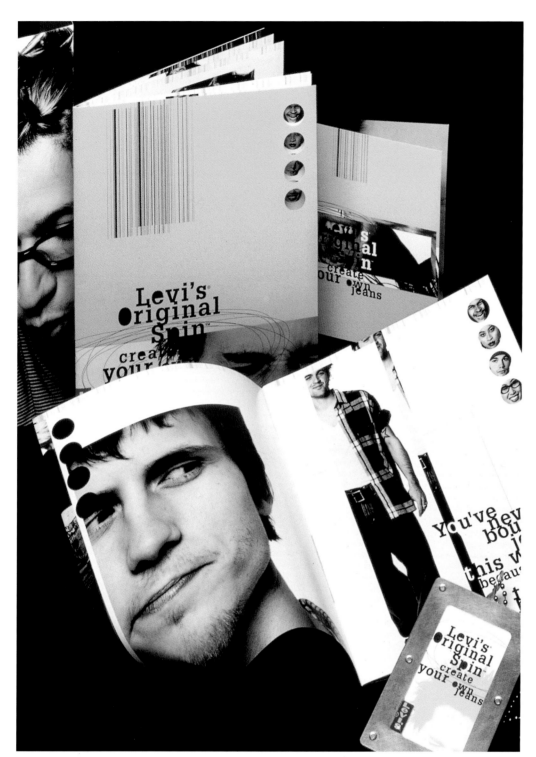

this page:
design
**JENNIFER MORLA,
ANGELA WILLIAMS**
art direction
JENNIFER MORLA
photography
JOCK MCDONALD
firm
MORLA DESIGN
client
LEVI STRAUSS & CO.

opposite page:
design
JEFF SAMARIPA
art direction
JOSÉ SERRANO
firm
MIRES DESIGN, INC.
client
MIRES DESIGN, INC.

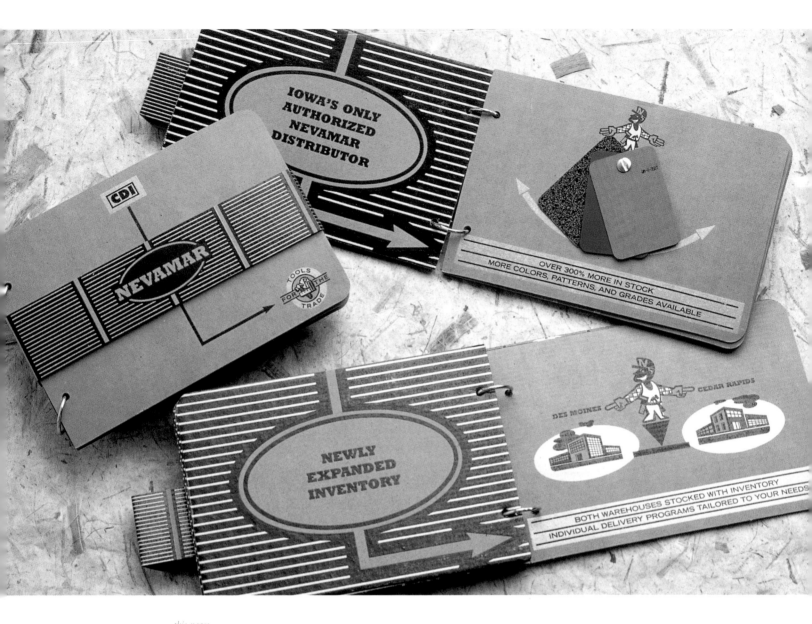

this page:
design
JOHN SAYLES

art direction
JOHN SAYLES

illustration
JOHN SAYLES

writing
WENDY LYONS

firm
SAYLES GRAPHIC DESIGN

client
CENTRAL DISTRIBUTORS INC.

opposite page:
design
CATHERINE LAM SIU HUNG,
QUENTIN TANG,
WALLEX LEUNG

art direction
CATHERINE LAM SIU HUNG

creative direction
JOE KURZER

firm
SATELLITE TELEVISION
ASIAN REGION LTD

client
STAR TV

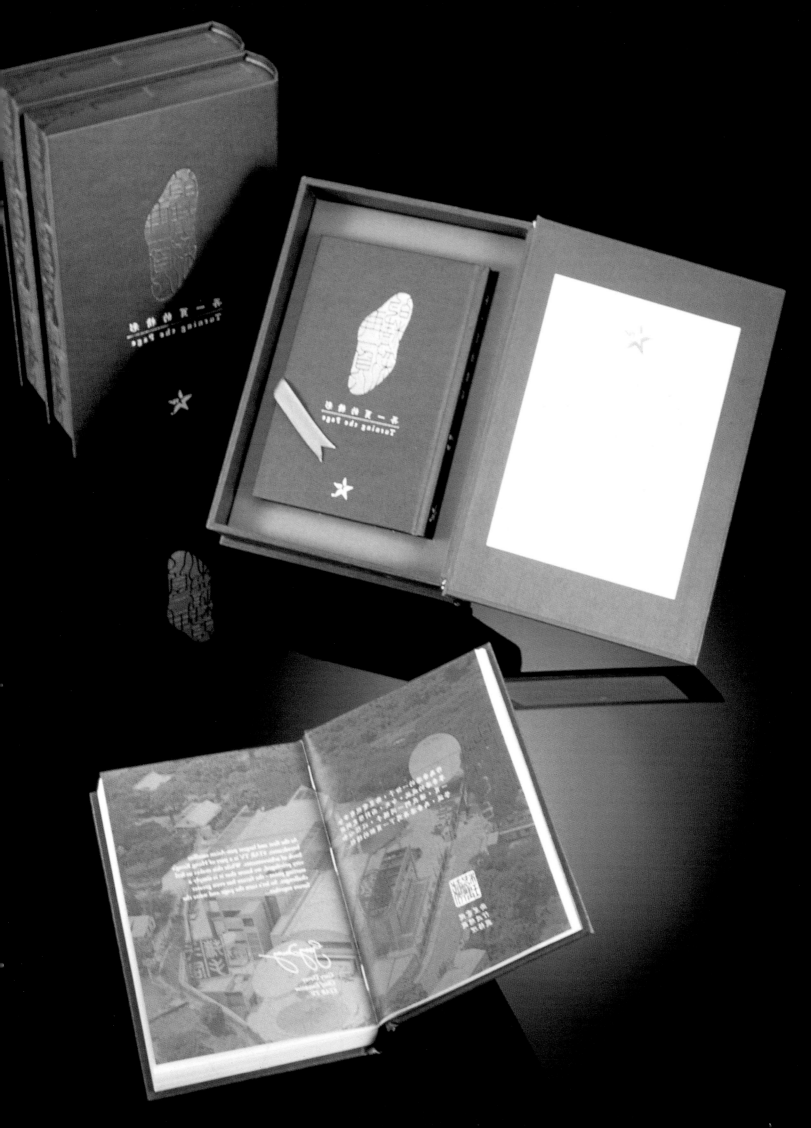

design
**KAN TAI-KEUNG,
YU CHI KONG,
LEUNG WAI YIN**
art direction
KAN TAI-KEUNG
chinese ink illustration
KAN TAI-KEUNG
photography
C. K. WONG
firm
**KAN & LAU DESIGN
CONSULTANTS**
client
**TOKUSHU PAPER
MANUFACTURING CO LTD**

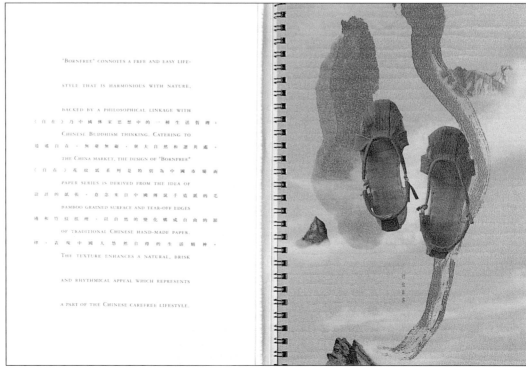

design
GIORGIO DAVANZO
art direction
LANNY FRENCH
firm
FOUNDATION
client
M SPA AND SALON

M
SPA
AND SALON
at Mettlers

DISCOVER A WAY OF LIFE FOR THE
THINKING MIND AND THE FEELING HEART.
FRESH IN SIMPLICITY.
MODERN AND BALANCED.
DISCOVER M SPA AND SALON AT METTLERS.
WE INVITE YOU TO COME IN,
ENJOY, RELAX, AND RESTORE.

M SPA AND SALON IS LOCATED IN THE UNIQUE,
TROPICAL SETTING OF ST. ARMAND'S CIRCLE.

35 S. Boulevard of The Presidents
Sarasota, Florida
Telephone 941. 388.1772

MASSAGE

Additional Massage Modalities Available

Myofascial Therapy · TMJ Disfunction Therapy · Craniosacral Therapy
Pregnancy Massage · Sports Massage · Structural Deep Tissue Therapy
Neuromuscular Therapy Energy · Integration Lymphatic Drainage Therapy
CONSULT SPA COORDINATOR
FOR ADDITIONAL INFORMATION AND PRICING

*Let off a little steam and escape the stress of everyday life with M Spa's
aromatic steam experience. Add a steam to any service for $10.*

BODY TREATMENTS

*Body treatments are designed not only to encourage rejuvenation and
longevity but to cleanse, detoxify and nourish the skin. Our wide selection
of treatments will meet your most specific needs.*

Hydro-Active Sea Salt Scrub
60 MINUTES $75
*Relaxing, invigorating, relaxing again. This treatment takes you on a
sensory journey transcending you into a new way of feeling. We combine
massage, body exfoliation with sea salt and essential oil, then remove
dry and dead skin cells with our overhead vichy shower, to invigorate
and increase circulation. We finish by wrapping you in a warm cocoon.*

Sea Salt Body Polish
50 MINUTES $45
*An invigorating sea salt and citrus body scrub
that leaves you feeling refreshed, glowing and smooth.*

BODY TREATMENTS

Herbal Detox Cocoon
50 MINUTES $60
*A relaxing, cleansing and healing treatment designed to help
rid the body of toxins and impurities. A special blend of
essential oils are applied, then your entire body is wrapped
in cotton sheets and cocooned in a thermal blanket.*

Enzymatic Sea Mud Wrap
60 MINUTES $75
*Detoxify and exfoliate your body with a warm purifying seaweed
and mineral poultice, uniquely wrapped to enhance relaxation.
Infused with aromatic botanical extracts and
fruit enzymes to leave the skin smooth and supple.*

Sea Algae Wrap
50 MINUTES $75
*A seaweed masque is applied to your entire body. Your skin
will be remineralized, hydrated and detoxified, while you are
wrapped in a warm cocoon. Our hydro tub will then remove
the algae with its bubbling action, while relaxing your entire body.*

Cellulite Treatment with Remodeling Toning Wrap
60 MINUTES $90
*A comprehensive treatment that addresses the circulatory
and aesthetic problems characterized as cellulite.
This synergistic program encompasses the application of mud,
special serum and creams, creating an essential toning body wrap.
We recommend a series of 6 over a 6 week period with monthly follow up sessions.*

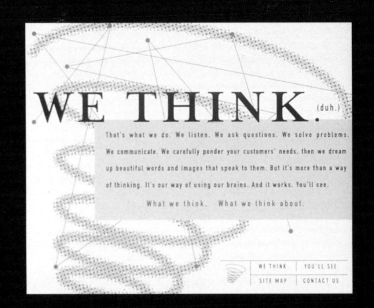

BREAKING THE RULES IN PUBLICATION DESIGN

electron
pub

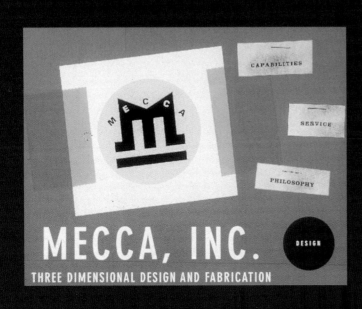

The new electronic interdependence recreates the world in the image of a global village.
—Marshall McLuhan

hether for Web sites or digital presentations, electronic publishing still follows certain design principles inherent in print. The visuals and text must be relevant, topical, and compelling. The content must be easy to digest and even easier to navigate. Ultimately, the communicative objectives of electronic publishing are the same as traditional media.

But the fixed nature of print is hardly comparable to the flexibility of electronic publishing. Today's technology offers a new level of immediacy, an instant access to information. New media allows a business to constantly shape its identity quickly and cost-effectively. By simply modifying a Web site or altering the look of a digital presentation, a company can not only keep pace, but stay one step ahead. The capability to update an image so easily projects an identity that is always connected to the marketplace.

The constantly evolving nature of electronic publishing, however, requires design discipline. The challenge is to blend the best of old media sensibilities with the technological power of new media. According to Chuck Johnson of Brainstorm, harnessing that technology is key. "One of the biggest difficulties of Web site design is that the visuals are changed so often, since the technology allows for it," says Johnson. "It can be a problem because when the design evolves that much, you sort of lose control of the original concept."

Evolutionary unpredictability aside, electronic publishing offers a world of opportunity for graphic designers. The Internet can reach people in a split second, and it can accommodate the content of a company's entire family of print pieces. With the click of a mouse button, customers can find all the latest information about a business—be it promotions, capabilities, services, or products.

Although electronic publishing introduces a whole new set of rules—such as image sizes, restricted fonts, and limitations of the user's equipment—it offers unique advantages. Web sites provide a device for archiving and information retrieval, and, perhaps most importantly, they allow people to not only glance at—but actually experience—a company or product. Whether watching colorful animation, clicking a mouse, or listening to an audio sample, the user is truly drawn in. "There's so much more freedom," says Patty Jensen of Jensen Design Associates. "With Web design, animation, and sound, we can open up a whole new way of thinking."

design
**CHRIS LAMY,
STEVE COSTANZA,
MARY JOHANNA BROWN**
art direction
CHRIS LAMY
programming
ERIC ANDREWS
firm
**BROWN & COMPANY
GRAPHIC DESIGN, INC.**
client
ZULU-TV

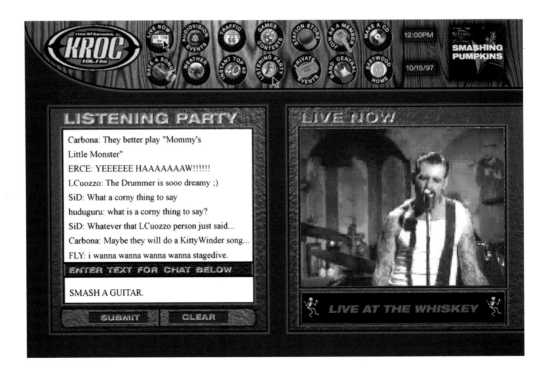

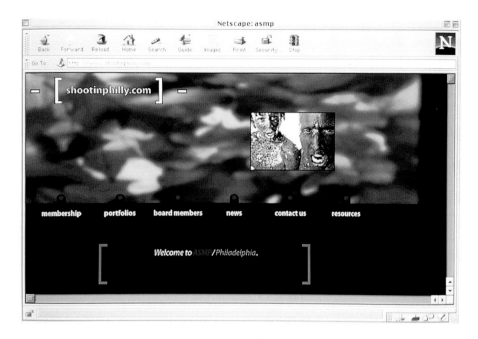

design
RICHARD CARDONA
art direction
RICHARD CARDONA
illustration
RICHARD CARDONA
firm
HYPNO DESIGN, INC.
client
**ASMP, PHILADELPHIA
CHAPTER**

166

design
**CHUCK JOHNSON,
WAYNE GEYER, JEFF DEY**
art direction
**CHUCK JOHNSON,
WAYNE GEYER, JEFF DEY**
creative direction
CHUCK JOHNSON
illustration
**CHUCK JOHNSON,
WAYNE GEYER, JEFF DEY**
firm
BRAINSTORM
client
BRAINSTORM

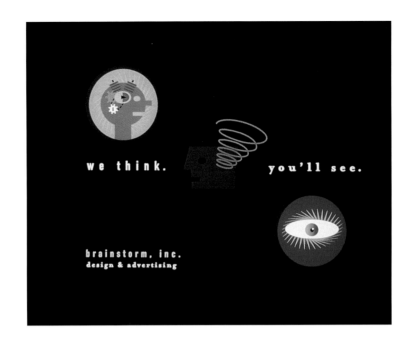

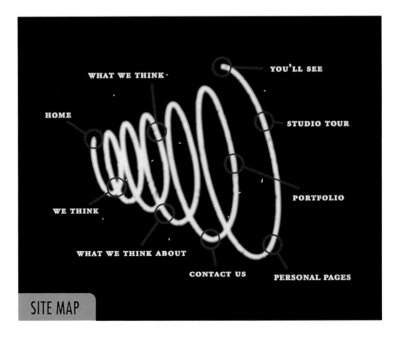

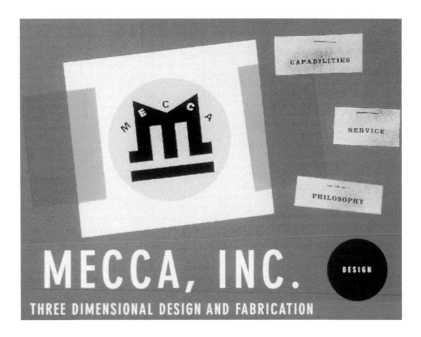

design
JEFF DEY
art direction
JEFF DEY
creative direction
CHUCK JOHNSON
photography
JEFF DEY
firm
BRAINSTORM
client
MECCA, INC.

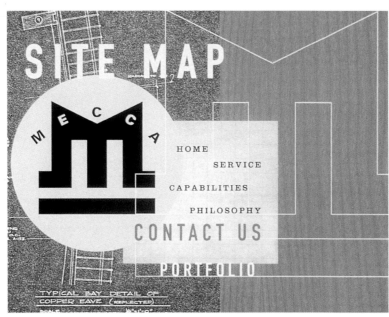

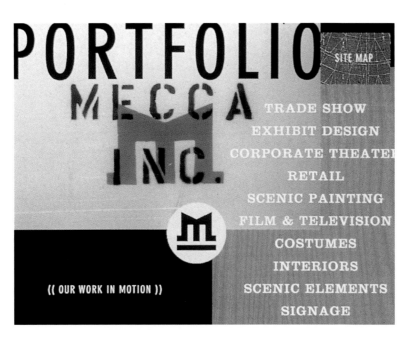

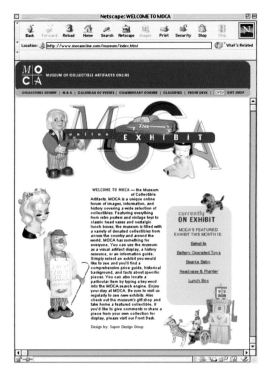

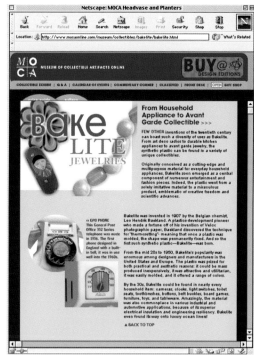

design
LILLIE FUJINAGA
art direction
SUPON PHORNIRUNLIT
creative direction
SUPON PHORNIRUNLIT
writing
STEPHEN SMITH
firm
SUPON DESIGN GROUP
client
MOCA ONLINE

JENSEN DESIGN ASSOCIATES

design
**DAVID JENSEN,
BOB RAYBURN**

art direction
DAVID JENSEN

programming
BOB RAYBURN

firm
**JENSEN DESIGN
ASSOCIATES INC.**

client
**JENSEN DESIGN
ASSOCIATES INC.**

IDENTITY
BRANDING · WORKING PAPERS

PACKAGING
PACKAGING · SIGNAGE · POINT OF PURCHASE

INDEX

IDENTITY
BRANDING · WORKING PAPERS

INDEX

PACKAGING
PACKAGING · SIGNAGE · POINT OF PURCHASE

design
STEVE COSTANZA

art direction
MARY JOHANNA BROWN

illustration
ERIC ANDREWS

programming
ERIC ANDREWS

firm
**BROWN & COMPANY
GRAPHIC DESIGN, INC.**

client
**ZERO EMISSIONS
TECHNOLOGY**

ZET

**Creative Minds
Working For
Breakthrough Solutions.**

Title Fuel Wet Low NOx SCR Fabric Filter Summary Utilities & ACT ACT Costs ZET
 Switching Scrubbing Burners Competition Installed Summary Summary

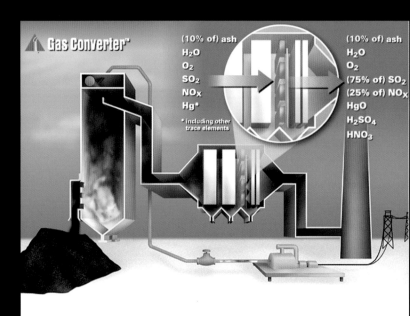

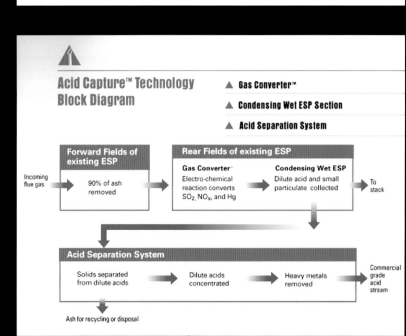

design
RICHARD CARDONA
art direction
RICHARD CARDONA
illustration
RICHARD CARDONA
firm
HYPNO DESIGN, INC.
client
HERR'S POTATO CHIPS

171

172

design
CATHARINE BRADBURY
art direction
CATHARINE BRADBURY
illustration
DEAN BARTSCH
photography
GREG HUZSAR
writing
LINDY MCINTYRE
firm
BRADBURY DESIGN
client
BRADBURY DESIGN

design
**MICHAEL SCHAFER,
LILLIE FUJINAGA,
CALDWELL WEGLICKI**
art direction
MICHAEL SCHAFER
creative direction
SUPON PHORNIRUNLIT
firm
SUPON DESIGN GROUP
client
BIG CHANGE NETWORKS

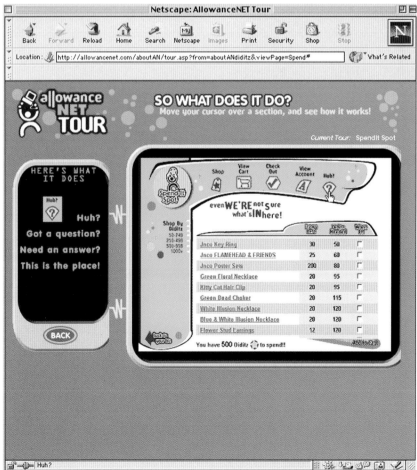

index

by design firm